ONE
PAINTING
A DAY

ONE
PAINTING
A DAY

A 6-WEEK COURSE IN OBSERVATIONAL PAINTING— CREATING EXTRAORDINARY PAINTINGS FROM EVERYDAY EXPERIENCES

TIMOTHY CALLAGHAN

Quarry Books
100 Cummings Center, Suite 406L
Beverly, MA 01915

quarrybooks.com • craftside.typepad.com

First published in the United States of America in 2013 by
Quarry Books, a member of
Quayside Publishing Group
100 Cummings Center
Suite 406-L
Beverly, Massachusetts 01915-6101
Telephone: (978) 282-9590
Fax: (978) 283-2742
www.quarrybooks.com
Visit www.Craftside.Typepad.com for a behind-the-scenes peek at
our crafty world!

10 9 8 7 6 5 4 3 2 1

ISBN: 978-1-59253-830-0
Digital edition published in 2013
eISBN: 978-1-61058-771-6

Library of Congress Cataloging-in-Publication Data
Callaghan, Timothy (Timothy H.)
 One painting a day : a 6-week course in observational painting--creating extraordinary
paintings from every day experience / Timothy Callaghan.
 pages cm -- (One a day)
Summary: "One Painting A Day offers you an inspiring six-week course exploring the time-
less traditions of observational painting through daily experience and routine. This motiva-
tional guide is broken up into three parts to focus on the three major traditions of observa-
tional painting: still life, landscape, and portraiture. Each of the 42 daily exercises launches a
small, immediate, and responsive painting based on a theme drawn from your daily experi-
ence."
--Provided by publisher
 ISBN 978-1-59253-830-0 (pbk.)
 1. Painting--Technique. I. Title.
 ND1473.C35 2013
 751.4--dc23
 2013008887

Cover and book design: Dominick Santise
Front cover images (clockwise, from top left): Timothy Callaghan (see page 48);
Amy Kligman (page 18); Timothy Callaghan (page 57); Harris Johnson (page 20);
Libby Black (page 47)
Back cover images (left to right): Timothy Callaghan (page 58); Cecelia Phillips (page 93);
Timothy Callaghan (page 72)
Spine: Timothy Callaghan (page 77)

Printed in China

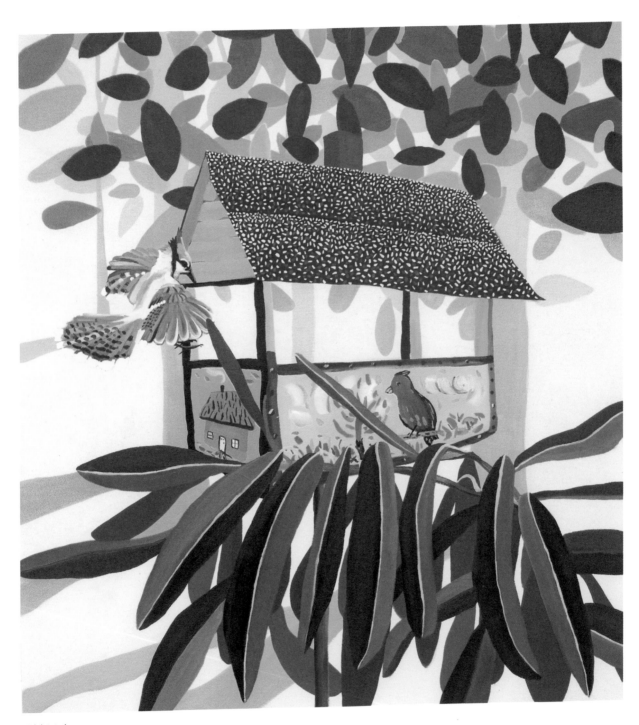

Old Maker

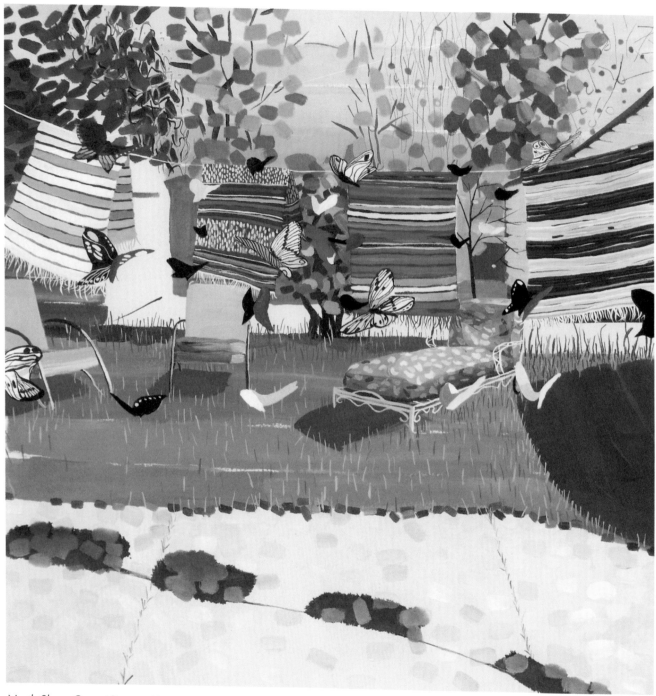

North Shore Carpet Beaters Union

CONTENTS

INTRODUCTION

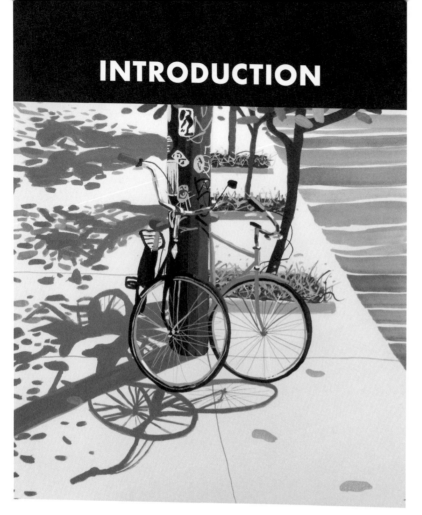

Necking, gouache

The secret to success in any creative field is a dedicated work ethic. Commitment to your practice is more important than any "natural ability" or "God-given talent." The craft of painting is no different; it requires the practitioner's love of the process and willingness to do it every day, even if it's only for a few hours.

No single book or particular instructor can teach you to paint. As artists, we teach ourselves through trial and error and repetition. While teachers and books are excellent resources, they are simply tour guides for the journey.

This book is such a guide, intended to inspire you to look around your local environment and respond to your daily experiences through the craft of painting.

Paintings describe the sensation of looking at something. They also describe how long it takes to look at something before you can actually see it. They are a visual conversation between you, the artist, and your viewer, describing your experiences and the things you look at on a daily basis. Painting is a poetic and ethereal language that allows for a nonlinear type of storytelling.

In representational painting, an artwork can fall into three major genres or categories: still life, landscape, and portraiture. Objects, space, and the figure (like nouns; things, place, and person) are the cornerstones of good storytelling. In this book we look at these three major formats, both independently and how they overlap to create paintings that tell our stories.

One Painting a Day is a commitment to a philosophy with rewards that can be seen every day. Each painting is a response to the last painting the artist made, an effort to make it better.

By taking this challenge of creating one painting a day, you have already succeeded. By the time you finish the forty-two paintings, your progress will be overwhelmingly gratifying.

The process of painting is typically thought of as lengthy, built up in successive layers. In many cases this is true, but there is an approach that is more immediate and akin to the spontaneity of a medium like drawing. This book is in part inspired by that approach: By working on a smaller scale and with quick-drying paints like acrylic and gouache, you can make one painting a day.

This book is also inspired by the first book in this series, Veronica Lawlor's *One Drawing a Day*. Within a six-week structure, Lawlor encourages her readers to build good studio habits and make a work every day without judging the results.

Working in the studio making paintings can be a very solitary practice, which is why having a community element to your studio habits can be very beneficial. Community has always been an integral part of my studio practice; I continue to include friends whose work I respond to into that process. We've exhibited together, share our progress, and talk about painting. Communication and collaboration becomes increasingly challenging once we leave the formal environment of school and our lives get busier, but technology and the Internet still make it possible.

For this book I've invited six painters—people whose work I've loved and known for a long time—to join me on this "one painting a day" journey. Even though we are spread all over the country, we still talk about painting and continue to share our progress

with one another. This is something you can do too. As you embark on this journey, invite fellow artists to take the challenge and share your progress.

The six-week course of forty-two exercises focuses on the major formats of representational painting, using both pure observation and photography as a reference.

Using the first week's worth of exercises as a springboard or course primer, we will look at all of the seven elements of art in relation to painting. Then, in Week 2, we begin to introduce narrative as a way to generate content and look for objects that inspire invention.

Weeks 3 and 4 are devoted to investigating space in our local landscape and discovering how the places we see every day can encourage inspired paintings.

The final two weeks of exercises are about the human element. We introduce portraiture and the figure to interact with the objects and space we have created.

This may seem overwhelming at first. Admittedly, when I began my own one-painting-a-day journey, at times it seemed impossible. Getting into the studio was the last thing I wanted to do.

Don't get discouraged if you have a bad day in the studio; it's part of the process. If you miss a day or don't finish a painting in the time allotted, simply double your efforts the next day. Most importantly, remember that by simply trying to make one thing a day, you have already succeeded.

CHAPTER 1:

GETTING STARTED

MATERIALS

The most important thing to remember regarding painting materials is that you get what you pay for. The cheapest brush or tube of paint may not always be the best way to go. Inexpensive paints aren't made from rich pigments, and therefore are very transparent and have deceiving colors. A poorly constructed brush will break down after a few washings and begin to shed. You will quickly find that having to replace your brushes frequently is not only annoying, but also inefficient: By the time you have replaced a lower-quality brush for the third time, you will have spent as much money as you would have if you had purchased the higher-quality brush to begin with. Certainly that doesn't mean you have to get the most expensive brush; there are many good options priced right in the middle. Experiment with different brands and price ranges.

Because painting supplies are so expensive, I follow a particular hierarchy in terms of how I buy them. Quality of paint is most important to me, so I spend the most amount of money on richly pigmented paints. Good brushes are important, but not as important as good paint, and so I spend significantly less money on them. Grounds aren't really an issue here because I make my own canvas or work on paper—even if it's really nice paper, it isn't very expensive.

If you choose to work on premade canvases, many options are moderately priced and of good quality. Most of the other materials you need you can find lying around the house, in your recycling bin, or at a hardware store for significantly less than you would find them in an art supply store.

PAINT

For the exercises in this book, I highly recommend using a water-based paint like acrylic or gouache, which is like a hybrid between watercolor and acrylic paint. For smaller works on paper and the paintings in this book, I used an acrylic-based gouache, which is very versatile and works great for quick paintings. Gouache's best quality is its opacity and flat saturated color. The downside of gouache is that it is impermanent; if you try to layer paint on top of paint that has already dried, the fresh paint will mix with the dry and make your colors muddy.

Acrylic paint is also opaque and dries very quickly, but it's permanent, so you can layer the paint. What I don't like, though, is its glossy look when it dries. You can add a matte medium to an acrylic paint to reduce the gloss, but this sometimes reduces the saturation of the color. An acrylic-based gouache combines the best of these two paints, so you get a permanent, opaque paint that is very rich in color and dries flat.

BRUSHES

You will need a wide range of brushes, varying in size and shape. The best affordable brushes that will last are made of synthetic hog's hair. You can use them for both acrylic and oil paints. In addition, I would get a few watercolor brushes; they are softer and are great for working with thin transparent washes.

GROUNDS

I prefer to paint on paper; a good, sturdy piece of water-color paper like an Arches or Stonehenge is great for the exercises in this book. The advantage of paper is that you can easily crop it down to any size or shape you like. If you prefer to work on premade canvas, you can usually find them in assorted sizes. You should get as many different shapes and sizes as you can find. Another option is to work on a sturdy piece of cardboard or thin piece of wood that you can prepare with a coat of gesso. The advantages of these grounds are that you can cut them down to any size and they are extremely affordable—in a lot of cases, they're free!

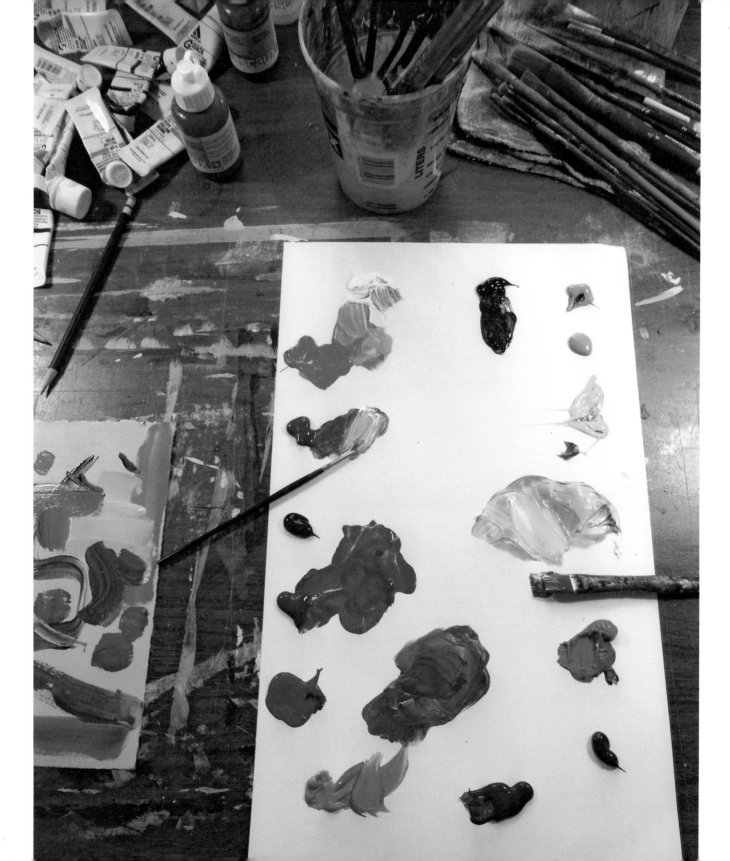

PALETTES, JARS, AND RAGS

You can find these items in any art supply store. Palettes come in a variety of sizes and are made from varying materials. The disposable palettes that come in a book are very convenient and make for easy cleanup, especially if you're traveling with your art supplies to paint on location. The type of palette I use depends on the circumstance. The bare essential for a palette is a neutral surface that will not absorb paint. You can simply attach a piece of gray or white paper to the back of an old windowpane. When searching for jars to hold water to clean your brushes, look for ones that have the widest mouth to accommodate many brushes. It's also a good idea to have a few; one for washing and one that stays relatively clean to thin the paint. You will also need a good supply of rags; you can buy shop rags at any hardware store or use old t-shirts and rip them into small pieces.

SKETCHBOOK, PENCILS, AND CAMERA

I prefer a smaller sketchbook that I can easily transport and always have in my back pocket. The leather sketchbooks that are bound, like Moleskine, are nice because they are very durable and the pages don't easily tear out. It's also a good idea to have a few pencils for drawing in the sketchbook as well as doing preparatory drawing on your paintings. I prefer very light graphite pencils when drawing directly on the surface that I plan to paint on. A point-and-shoot digital camera is also essential, not only so that you can take reference photographs for paintings, but also so that you can photograph your paintings and share your progress.

OTHER HELPFUL TOOLS

I prefer to paint directly on the wall or on a table, but sometimes I need to use an easel. For the exercises in this book, a portable easel might be a good investment, but it isn't required. You can create makeshift easels from chairs and even ladders; a drawing board also can function as an easel. In addition, a tackle box is a good idea for when you have to travel with all your materials. Essential items to carry in your tackle box along with your painting materials are masking tape and a small drop cloth. A personal computer is another helpful tool for this journey, but it isn't required. It can come in handy if you want to print your own reference photos quickly and affordably. You may also consider using some social media element with this project and start a simple blog page to document and easily share your progress with your community.

STUDIO AND LOCATION

Studios come in all shapes and sizes. Having a studio outside your home is a luxury but certainly not a requirement for the exercises in this book. I have worked in all types of studios throughout my career, from large warehouse spaces to garages—even a small corner in the basement. A separate room in your home can be ideal because you can leave your work and supplies set up permanently and come back to them whenever you have time. Or, a studio can simply be a table in your home, with some wall space adjacent to it so that you can pin up in-progress works.

Whatever space you choose to work in, you want to make it inspirational and comfortable, a place you feel like going to every day to make paintings. Whenever I

move into a new space, I like to pin up postcards and pictures of paintings that I admire. I also like to designate a place for all my favorite artist books and a comfy chair to sit in while looking through those books when I need a break or feel stuck when I'm working on a painting. Music is also very important when I work, so a stereo is a must for me in the studio. Plants are great to have in a studio space too: They are forms to paint and include in still lifes, and they add to the atmosphere of your space by providing inspirational color.

TABLES AND EASELS

To furnish your studio, you may want a drafting-style table that tilts and is specifically designed for making art. In my studio, I have a large, sturdy folding table so that if I want to work on a larger scale and need more space, I can easily fold it up and move it out of the way. It's also a good idea to have a few smaller tables, preferably with wheels, but you could instead use fold-up TV trays or something similar. Easels also come in different shapes and sizes and vary in price. I don't have an easel in my studio; when I want to paint upright I prop the painting on the wall with cinder block. If you choose to purchase an easel, look for one that is collapsible and easily portable for working on location.

STORAGE

Somewhere in your workspace, you will need to designate a place for storing finished and in-progress works as well as your art supplies. A small shelving structure for holding materials will work well; you can usually find one at any hardware store. You should also designate a space to store your work safely. If you're working on paper, a flat file is a great shelving system to sort and stack paintings. Another option is to store your work in a few large, flat portfolios.

LIGHTING

Good lighting is one of the most important elements in the studio. A space with one or two windows that receive a lot of daylight is ideal. In addition, you will also need clamp lights for working late into the evening and lighting your subjects. The clamp lights that you can find at any hardware store are the best because they can be moved around the studio easily as needed throughout the day. It's a good idea to get a few different bulbs to use in the clamp lights. Get both fluorescent and daylight bulbs so that you can balance warm and cool light.

SEATING

A comfortable chair is a must in the studio when you're working at a table; a chair whose height you can adjust will be very useful. In addition, a chair that has wheels is a good idea so that you can push yourself back from your painting periodically to look at your work from a distance. A tall stool is another piece of furniture you might want to consider when you're working on an easel or directly on the wall. Whatever type of seating you choose, it's important to also stand once in a while when you paint. That way, you can look at the work from different distances and see the painting as it is developing.

WORKING ON LOCATION

When you're working outside your studio on location, you'll want to be as efficient as possible and travel light. Use a tackle box or toolbox to create a movable studio filled with all the supplies you will need to make a painting away from your studio. Whenever I travel to someone's home to make a portrait or work outside to paint a landscape, I have a separate kit that I can travel with.

In addition to paint and brushes, you want to fill your kit with these items:

1. Jars with tight-fitting lids filled with water for cleaning your brushes and thinning your paint. Two jars should be sufficient.
2. A small drop cloth that you can fold up if you're painting in someone's home, as well as plenty of rags.
3. A roll of masking tape. This can come in handy for taping a piece of paper to a drawing board to paint on, or if you want to mask off an area in your painting.
4. Your sketchbook and pencils for doing thumbnail sketches and preparatory drawings.
5. Your camera for taking reference photographs in case you don't finish the painting on location.
6. A disposable pad of palette paper. This is very convenient for painting on location and small enough to easily transport.
7. A few plastic bags. You can put dirty brushes and rags in them, so once you have finished you can pack up without making a mess in your travel kit.

If you choose to purchase a portable easel, look for one that folds into a box; it will give you additional storage for painting supplies. You can also use a folding chair and a drawing board to function as a makeshift easel/workspace.

Finally, a portfolio case with a shoulder strap for carrying your work is a helpful tool, one that allows for more storage of miscellaneous items that may not fit in your tackle box.

On location

PART I: STILL LIFE: THING

"It's the very process of looking at something that makes it beautiful."

—David Hockney

Pitch-In, acrylic and resin, by Amy Kligman

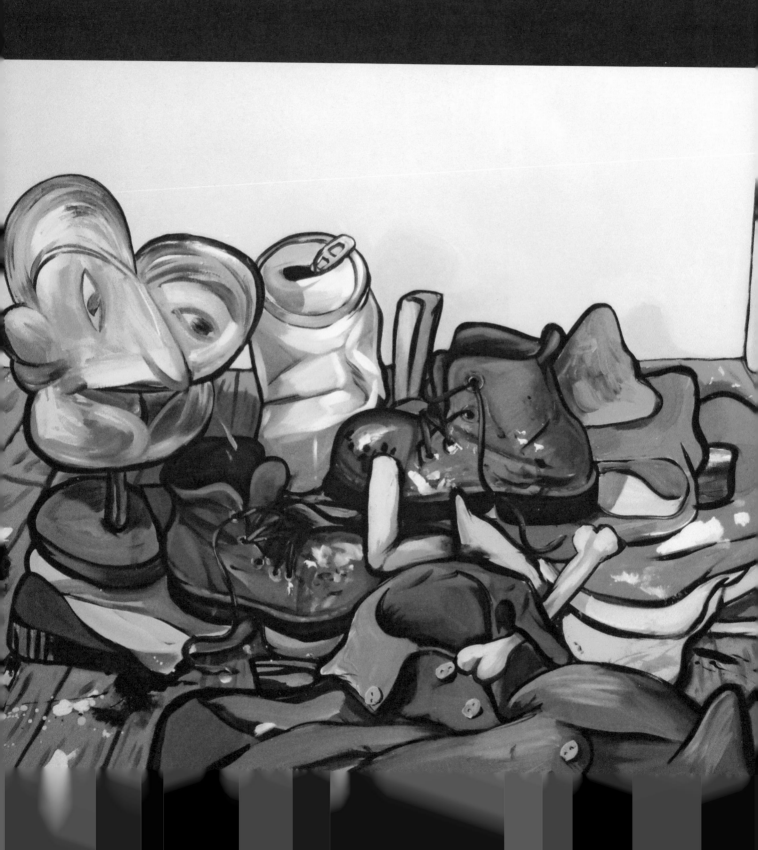

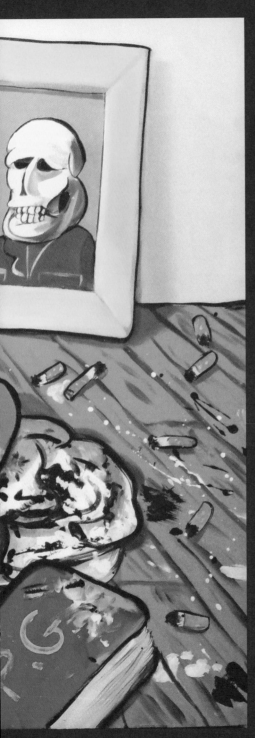

CHAPTER 2
STILL LIFE AS LABORATORY

When learning their craft most painters begin by painting a still life. The practical and direct exercise of grouping objects and studying them is an important first step toward understanding mark making, color, and form. Yet even the most skilled painters return to still life to experiment or sharpen their skills.

I often use the still-life format as a device to refresh after finishing a body of work or to experiment with a new painting technique. All the elements of art can be explored through painting objects from observation. Choosing and grouping objects that are the most appropriate to emphasize the particular element you're focusing on is beneficial. Another attractive attribute of the still life is its accessibility; a still life can simply be the objects lying on your worktable. These first seven paintings are devoted to exploring the seven major elements of visual art using common, everyday objects.

Messy floor with DeKooning sculpture
spitting tobacco, acrylic on canvas,
by Harris Johnson

LINE
DAY 1

The most basic element of art is line. Although line is most commonly associated with drawing, there are a lot of linear elements in painting. For example, the negative space between marks creates lines, as do the width and length of the brushstrokes themselves.

Line is usually what every painter starts with, whether it is a pencil sketch or the lines of an underpainting. A line documents our eyes following the edge of a form.

For this painting, I chose a few linear objects in my studio and placed them on my floor to look at the contrasting types of lines simultaneously. The rectilinear lines of the floorboards and the curvilinear lines of the power cords made for a great study about line.

EXERCISE 1
Choose a few objects in your home or studio that lend themselves to painting a variety of different qualities of line. Objects like kitchen utensils would be great subjects for this exercise. You could even use your painting materials— pencils, brushes—to make a still life.

TIP

When exploring lines as a motif in your own painting, remember to spend just as much time looking at your painting as you do looking at the still life. Accuracy in depiction is not as important as the quality of lines and marks in the painting. When painting these lines, choose the appropriate size brush for the width of the lines you're depicting. Make sure to add a lot of water or thinner to your paint to get a very fluid consistency.

Detail

Knot, acrylic and ink

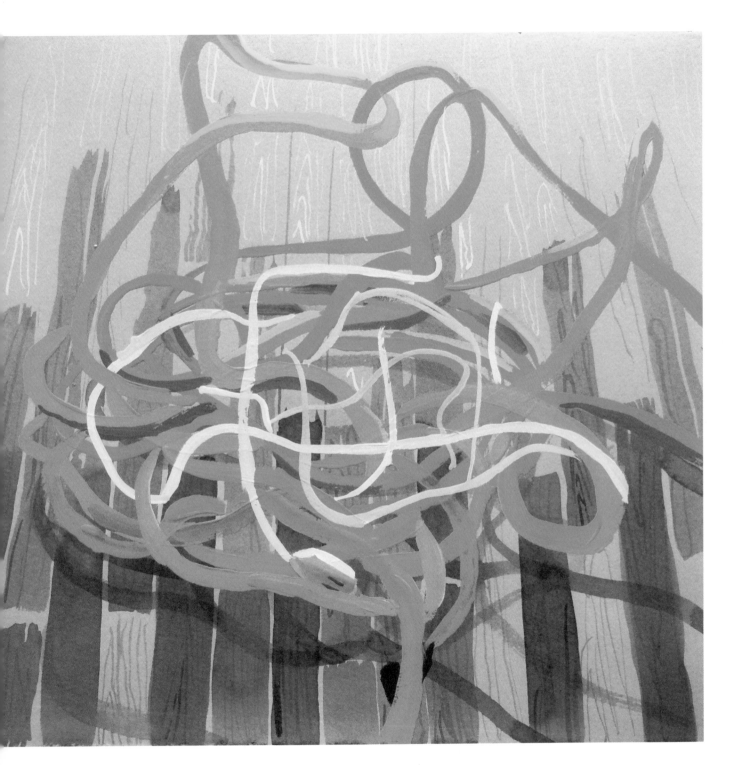

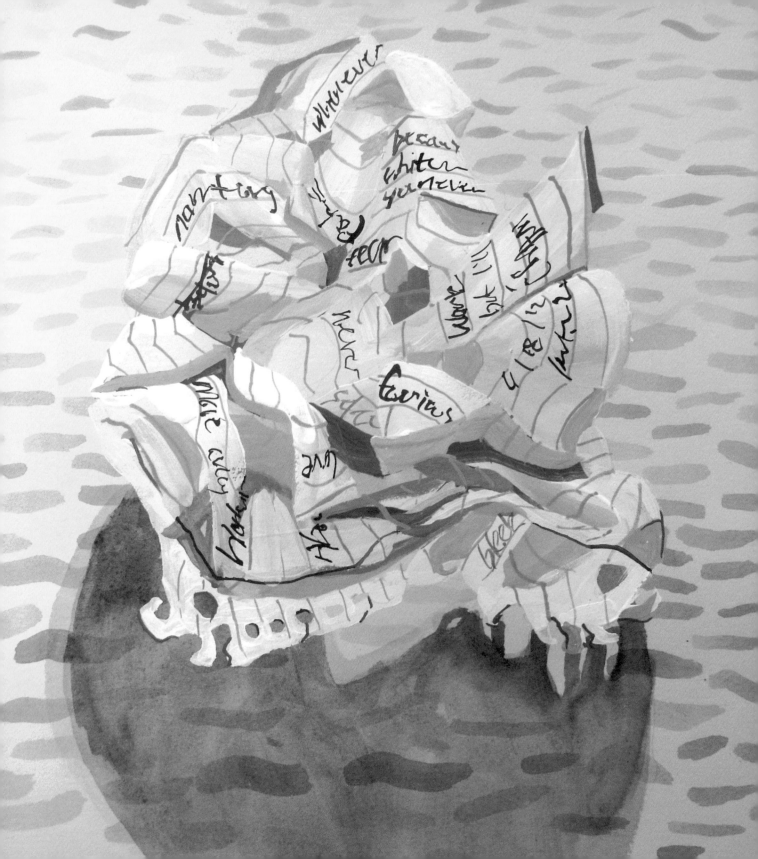

VALUE
DAY 2

Value refers to the relative lightness or darkness of a color. In representational painting, the most fundamental application of value is to give a two-dimensional shape a volumetric form. This is achieved when a color moves from dark to light in gradual shifts within the shape. Value also refers to light and how it informs the subject in a painting. For this painting, I wanted to explore these concerns with one object and a limited palette. I chose to look at a crumpled piece of notebook paper with the light source behind it in order to show very subtle shifts in value and a dramatic cast shadow.

EXERCISE 2

A white still life is a great subject for exploring value. Choose one to three objects that are white or at least are neutral in color. Light your subject with a direct source, like a lamp, so that you can see the shifts in value from light to dark on the objects, as well as on the cast shadows.

Detail

Discarded Love Letter, gouache

TIP

If you choose to use a limited palette, try to experiment with color rather than black paint to darken the colors. For my painting, I used only blue, sepia, and white. You can also choose two complementary colors like blue and orange to create a neutral darker color to mix with the white. You don't have to necessarily blend all the values to create volume, but you do need to have a full range of value in order to give the objects a volumetric form.

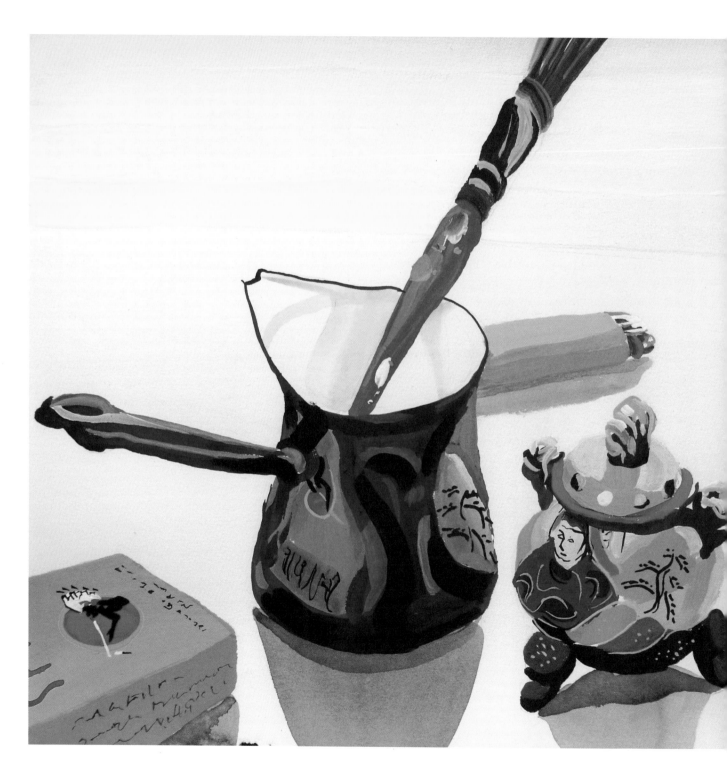

COLOR
DAY 3

The painter Josef Albers said, "Color is the most relative medium in art." Anyone who works with color knows it can also be the most exciting and magical. All the elemental rules or theories of color in regard to pigment can be discovered through a basic color wheel.

A good way to begin exploring color and its "relativity" is to paint a still life with objects that share the same hue. Hue refers to the name of a color, and while there are only about twenty different hues, there are literally thousands of different colors and variations of a particular hue. For this painting, I chose to work with an analogous color scheme using only blue objects, ranging from a cool, deep blue-violet to a warm, pale blue-green. An analogous color scheme refers to colors that are located directly beside each other on the color wheel, which results in a very unified palette.

EXERCISE 3

Choose a few objects that share the same hue and set up a still life to paint from. Light the subject in direct light to observe the different temperature and value shifts in the colors of the objects.

TIP

Working with a particular color scheme is a way to limit your palette to just a few colors that will create harmonious color relationships. Working with limitations, especially in color, ensures unity and encourages creative problem solving. If you choose to work with an analogous color scheme, try to use as many different types of the chosen hue as you can find. For instance, in my painting I used a cobalt blue, a Prussian blue, and a cerulean blue to have a broader range.

Detail

Blues, gouache

Progress 1

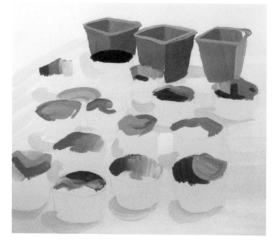

Progress 2

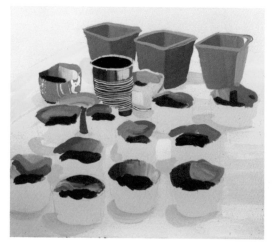

Progress 3

SHAPE
DAY 4

If line is the most fundamental element of drawing, then shape is the most fundamental element of painting. Drawing is the process of finding the edge of a form, whereas painting is the process of depicting the shapes within those edges. The size and shape of the marks you make depend on the size and shape of the brush you choose. I regularly look for the most efficient way to fill space with shapes and planar marks, and choosing the right brush is key to this approach. For this painting, I wanted to isolate just a few shapes and repeat them throughout the painting. The ellipse, a circle viewed at an angle or in perspective, dominates this composition. The torn edges of the aluminum cans interested me because of all the variations on that simple shape.

EXERCISE 4

For this still life, choose objects that share similar shapes to paint from. Choose your brush size in relation to the size of the shapes you're depicting.

When choosing a brush size, I usually reach for a brush whose shape and size most efficiently cover the shape that I'm filling in.

The Restless Lovers' Garden, gouache

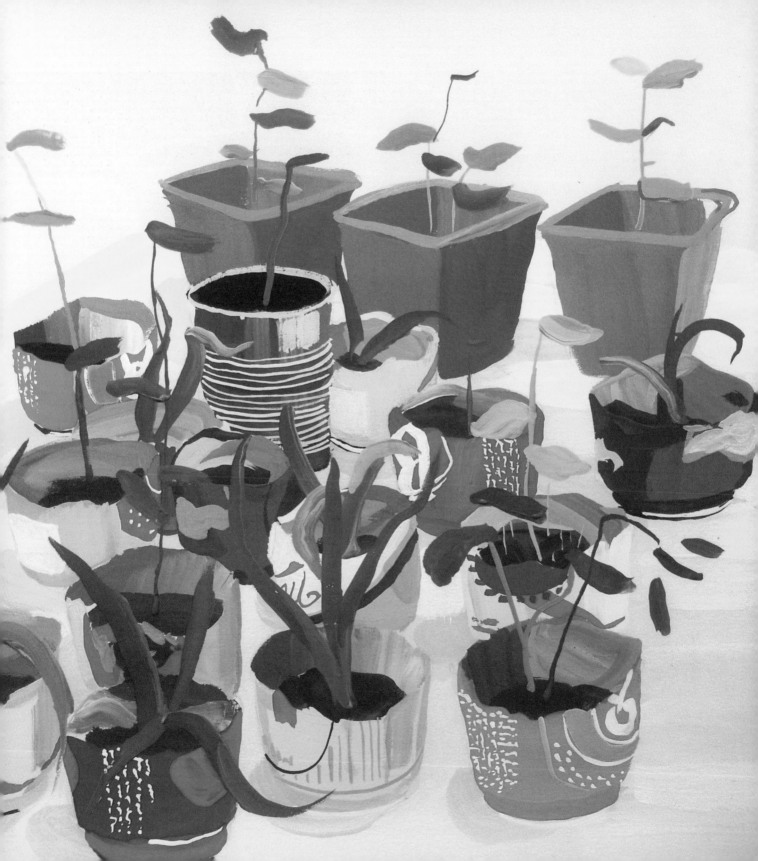

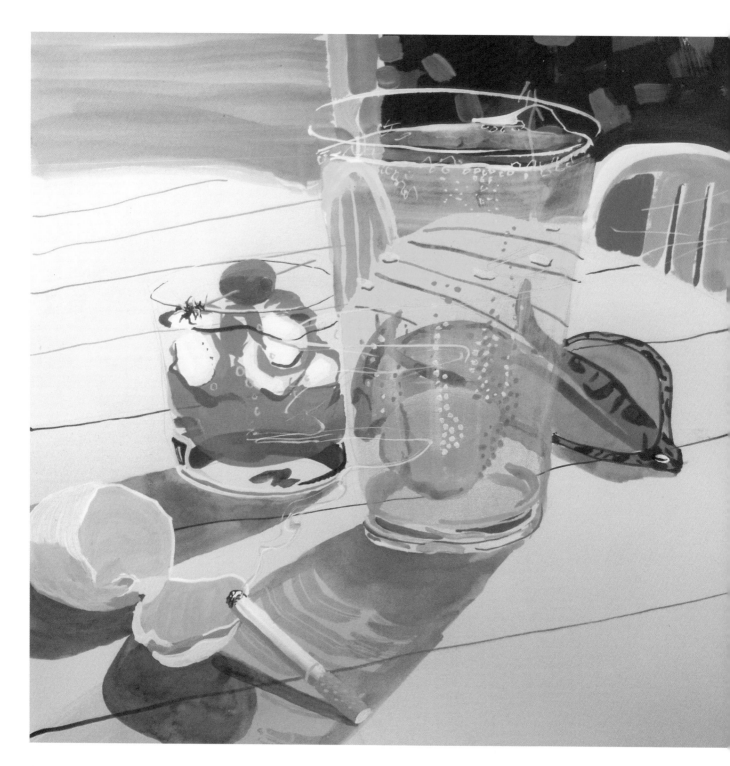

FORM
DAY 5

The form of a painting is a flat picture plane that is measured in height and width. Since painting is distinct from three-dimensional art like sculpture, painters are concerned with how to present an image in only two dimensions. This limitation is exciting, and its success depends on how we organize space in relation to the edges of the canvas and balance the visual weight of the forms that exist in that space. In regard to the still life, cropping an image and allowing the forms to extend past all four edges is a highly effective way to divide the space into visual pathways for the viewer to follow throughout the picture.

When thinking about the balance of visual weight, I like to apply the rule of threes, as in large, medium, and small. For this painting, I chose to look at different types of containers to observe their relative proportions and scale within the tightly cropped space.

EXERCISE 5

Set up a still life of three or four objects that vary in size and shape. Begin with a few thumbnail sketches that focus on the painting's compositional elements.

TIP

Another interesting challenge when addressing the issue of form is to give shape to seemingly formless elements. In this painting, I wanted to observe liquid, glass, and smoke and to tackle the subject of distortion. When attempting to articulate the atmospheric qualities of these elements, it's helpful to paint what is behind them first and use transparent washes to build the space from back to front.

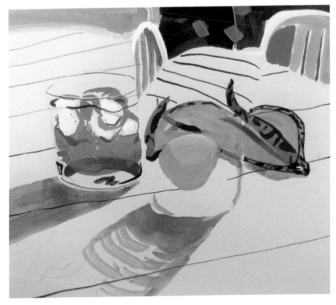

Mid-progress

Fun House, gouache

SPACE
DAY 6

Space in painting is an illusion and isn't generally considered a major concern in still life because of the shallow depth of field. However, creating a larger depth of field in a still life can be an interesting exercise. There are many ways to exploit the illusionary space in painting, including the use of linear perspective.

In my own painting, I prefer to use what is known as atmospheric perspective. In this approach, the space is generally divided into three areas or grounds: foreground, middle ground, and background. For this painting, I chose to look at three large objects in my driveway and arranged them to correspond with the three areas of space. The space in the painting, which is viewed from bottom to top, gives the illusion of front to back because of three simple conventions. First, the objects reduce in size as they move up the page. Second, the objects overlap one another. And third, the greatest amount of contrast is relegated to the foreground and decreases gradually as it moves back in space.

EXERCISE 6

Choose at least three objects and space them apart to create a deeper depth of field. Use a vertical composition that emphasizes the bottom of the picture as the foreground.

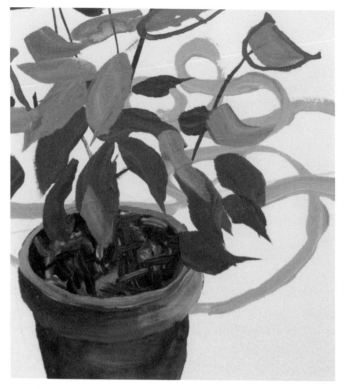

Detail

TIP

Contrast is how painters arrange value and color next to each other. In the rules of atmospheric perspective, you want to have the greatest amount of contrast in the foreground and allow the contrast to diminish gradually as you move into the middle ground and background. By placing high key values (light) directly next to low key values (dark), you will achieve high key contrast.

Water Down, gouache

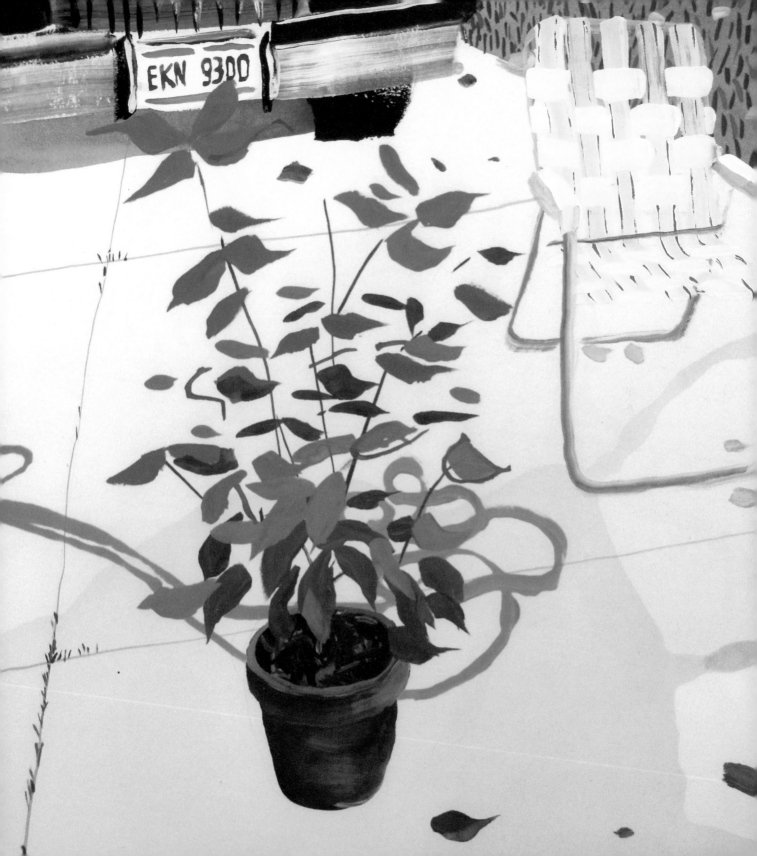

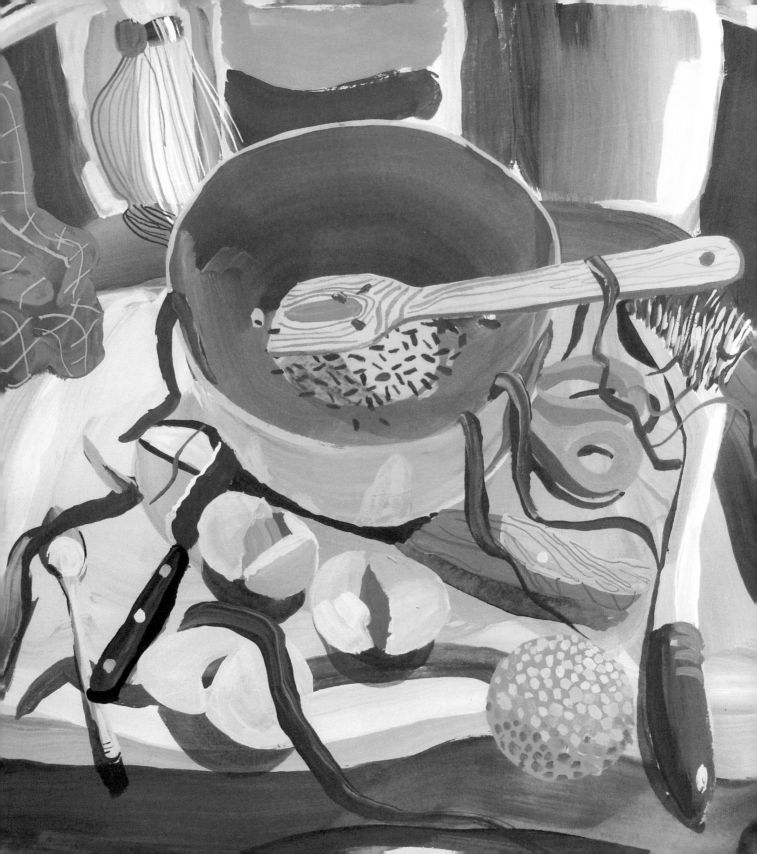

TEXTURE
DAY 7

Texture, which is about the quality of the painting's surface, is a great way to activate the sense of touch. A painting can have two types of texture: actual and simulated. Actual texture can be created with a brushstroke and can vary depending on how much paint you use. *Impasto* refers to the buildup of very thick paint and can be very tactile.

Simulated texture is an illusion to give the appearance of a textured surface through the accumulation of similar and repetitive marks. For example, in my painting I used very thin white paint to paint the reflective surface of the whisk, but very thick white paint to paint the whiskers of the scrub brush.

I always enjoy seeing both types of texture in a single painting, and I try to employ both in my own work. For this topographical still life, I was looking at dirty dishes in the sink and investigating the contrasting types of textures.

EXERCISE 7

Choose a group of objects with various types of textures to use in a painting. Apply the paint using both actual and simulated texture.

TIP

When exploring texture as a subject in your painting, it's helpful to actually hold the objects in your hands to investigate their individual surfaces. The sensation of feeling them before you begin painting can lead to ideas for all the different ways you can apply the paint that wouldn't come from just looking at the objects. For example, if something feels bumpy, you can apply the paint with thick repetitive dabs of paint to achieve an actual texture that mimics the surface you're looking at.

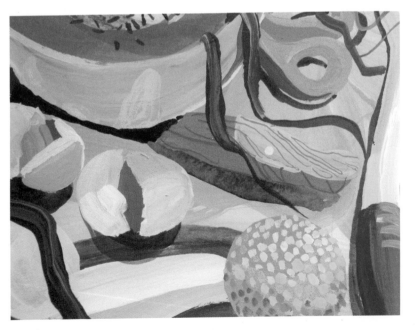

Eggs and Chives, acrylic and gouache

Detail

OBJECTS AS NARRATIVE

As we explored in the preceding chapter, the still life is an excellent format for isolating objects or moments in order to focus on something in particular. This same approach can also be a great way to suggest a narrative or create a particular mood. The objects we possess tell stories about our lives, and the ways in which we present or find them arranged can be very revealing. I have always been attracted to an open-ended style of storytelling and nonlinear narratives, similar to the fiction of Don DeLillo, because of their similarities to painting. It's an appealing challenge to suggest a story with only one image—one that invites creative problem solving and requires subtle invention. The limitations of creating a story out of only objects in space can seem challenging, but in fact the limitations are what activate the creative problem-solving process.

These next seven paintings are dedicated to using both the format and the limitations of the still life to create exciting microfictions based on your daily life.

Yellow Daffodils, oil, by Libby Black

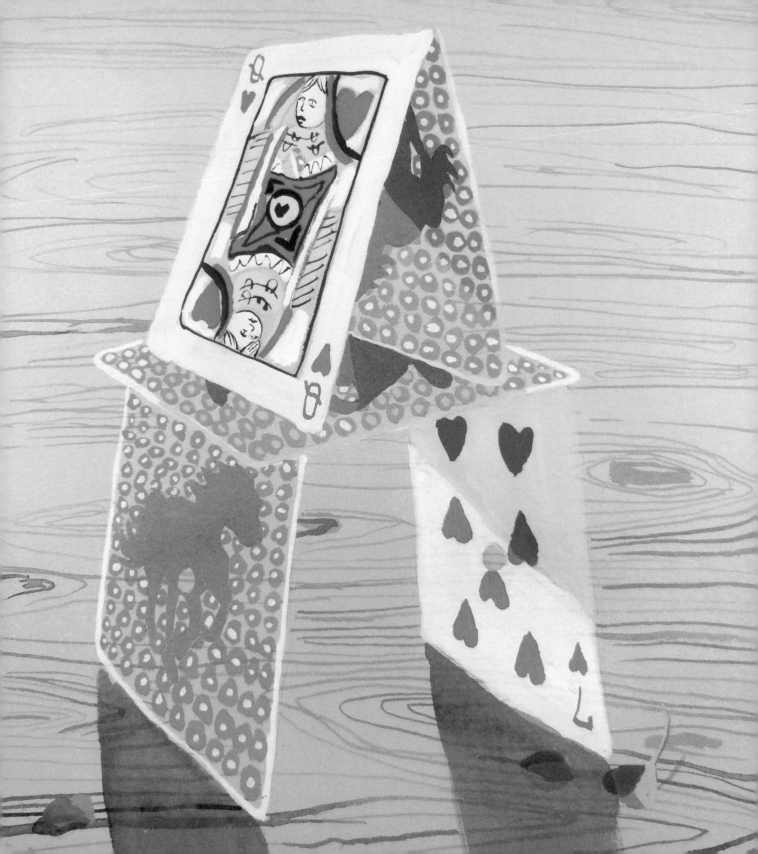

SONG STILL LIFE
DAY 8

A good way to start thinking about creating a narrative with a still life is to use someone else's words for inspiration. A song or poem is the perfect length from which to extract visual information and begin building a story based on objects. For this painting, I wanted to create an image based on one of my favorite songs: "Let Me See The Colts," by the band Smog. It's a very suggestive and moody song in which the protagonist is pleading with an unidentified character about letting him "see the colts that will run next year"; there are great references to gambling and luck. I wanted to present an image of colts running in an intimate and fragile context. I couldn't find the right playing cards with horses on them, so I invented my own and set up a small house of cards to emphasize the fragility of the song's theme. I found an image of a colt running and did a few drawings of how it would look as a graphic element on a playing card in perspective.

EXERCISE 8

Pick one of your favorite songs and pull out a few visual moments to use in a painting. Listen to the song repeatedly during the process and allow the music to inform your choices in color and light.

VARIATION

Another way to approach this exercise is to choose a longer narrative to work from. In Cecelia's painting, she is responding to the short story "Nobody Said Anything" by Raymond Carver. She chose to isolate a single image at the end of the story that struck her as a visual moment, summing up the story's mood and atmosphere.

Still Life for a Gambling Man, gouache and ink

Raymond Carver Story, oil, by Cecelia Phillips

STUDIO STILL LIFE
DAY 9

The studio is an excellent setting for a narrative, whether it's your own or someone else's workspace. I spend a lot of time in my studio simply looking at things, like how the light falls on a jar, or paintbrushes lined up in a row. The gestation period of the creative process is sometimes the most productive part of painting. The conversations that take place in studios—contemplating ideas with a peer or even talking out loud to yourself while waiting for something to dry—are also a strong component to this narrative. My partner is a seamstress. Her tools are very different from mine, but our process isn't so dissimilar. For this painting, I wanted to paint a still life in someone else's workspace and capture this moment of waiting, thinking, and quietly looking.

EXERCISE 9

For this painting, set up a still life in your workspace using your tools as objects and make a painting that suggests the creative process. For example, you could make a still life that suggests the beginning of the process by stacking fresh canvases and new tubes of paint into a pile.

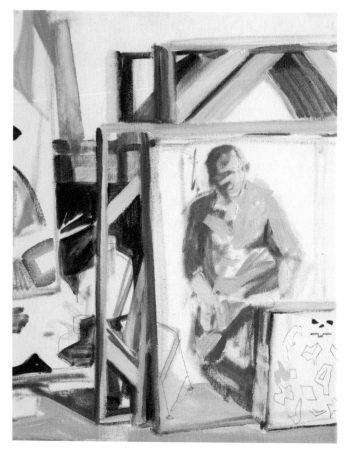

Studio Still Life, oil, by Matthew Johnson

VARIATION

If you choose to paint your own workspace, an interesting variation is to make a painting from your previous paintings. In Matthew's painting, he observes the three-dimensional qualities of his previous canvases with cast shadows and even includes details that suggest unfinished and in-progress works of art.

Fashion Shirt Fashion Style, gouache

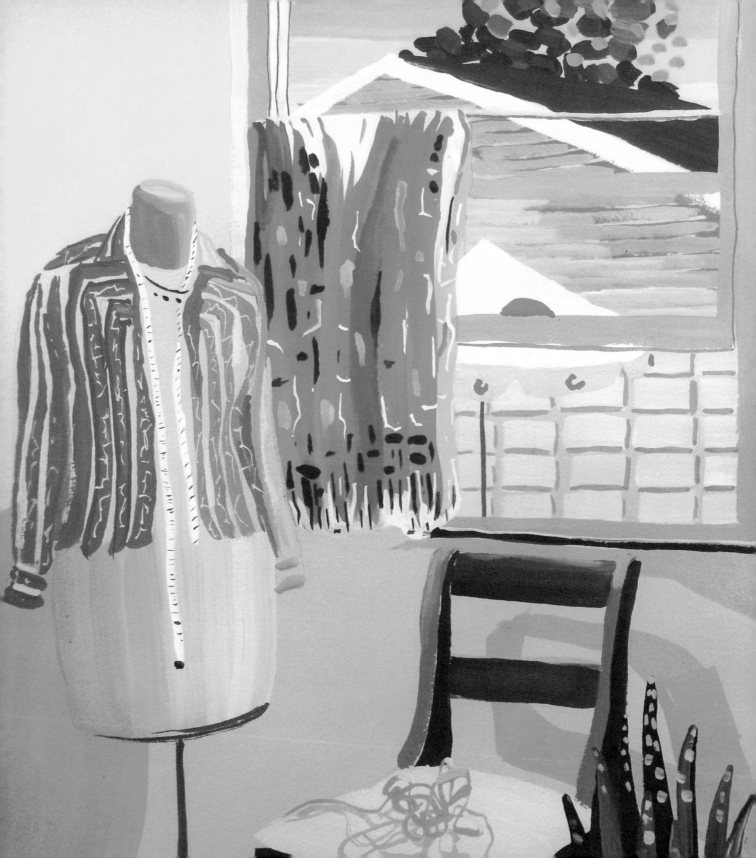

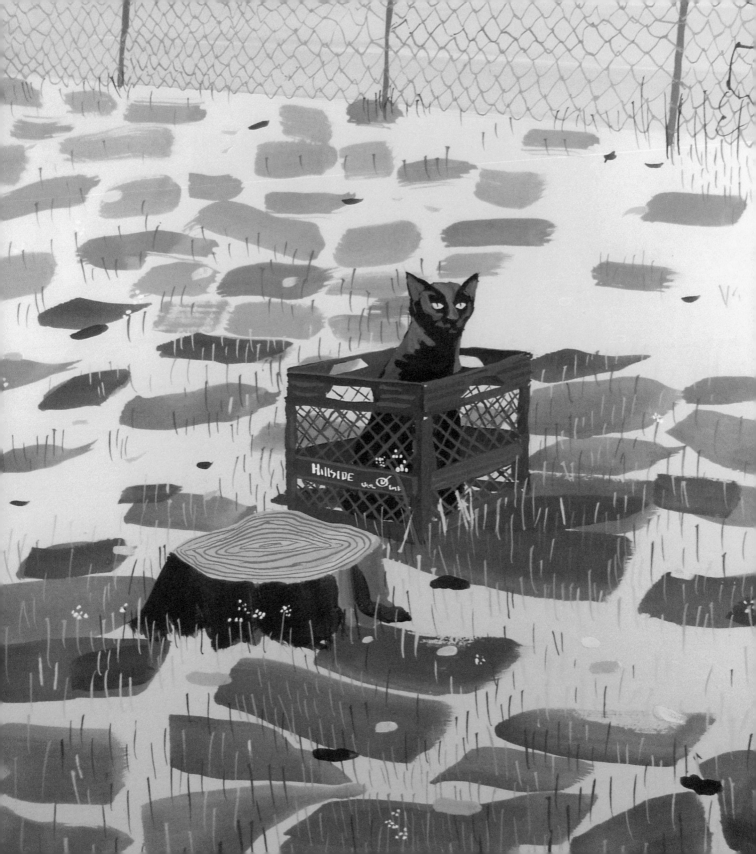

FOUND STILL LIFE
DAY 10

Often while riding my bike or taking a walk, I like to make up stories about discarded or awkwardly arranged objects I find during the journey. Recently, while on my way to the studio, I came upon a cat investigating a milk crate in a vacant lot. Unfortunately, I didn't have my sketchbook or camera with me, so a lot of this painting is re-created from memory. Much of the narrative of this painting wasn't so much from the scene I witnessed as it was from a response to Matthew's painting *Note*, in which he is responding to a found note. With the help of a milk crate in my studio and photographs of my own cat, I was able to reconstruct this funny little moment that documents my memory and responds to the narrative of Matthew's painting.

EXERCISE 10

Take a walk through your neighborhood with a sketchbook and a camera, and look for objects that were left behind. When you come across something that strikes you as peculiar, accidental, or maybe funny, photograph it or do a quick sketch of the scene. Then make up a story from the picture and make a painting that suggests the who, what, or why in this found still life.

TIP

Include a detail about location or context that emphasizes the "found" nature of the objects. In my painting, the narrative of the missing cat is created through the empty space that surrounds the milk crate. The detail of the fence with vines suggests the displacement of the object's surroundings.

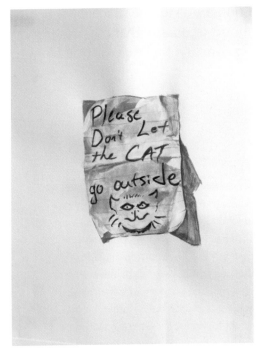

Cat in the Box, gouache

Note, watercolor, by Matthew Johnson

STORAGE STILL LIFE
DAY 11

Storage spaces, like a closet, drawer, or garage, can be interesting subjects for a still life. These places are packed with objects that are not arranged in any particular stylistic manner, yet hold much potential for suggesting narrative. It is fascinating to observe how and why we organize our belongings and what this can reveal about our character, personality, or mood. Visually, these spaces hold many possibilities for nontraditional still-life compositions that flatten the space and isolate the object's qualities.

For this painting, I was looking into a closet that was nearly empty and wanted to emphasize the sparse features of the objects and their relationships to one another.

EXERCISE 11

Look for a storage space in your home that has a mood or quality that particularly reflects your personality. Make a painting from it.

TIP

Before starting this painting, it may be helpful to do a few quick thumbnail sketches focusing on the painting's composition. Look for repetitive motifs that suggest pattern. To achieve a more compact composition, zoom in on your subject and crop any information that refers to the room where the storage space is located.

VARIATION

An interesting variation on this theme is to completely invent a storagelike structure and the objects in it. In Harris's painting, he presents us with an image of a makeshift shelf where the objects are self-referential to his artistic influences and sense of humor.

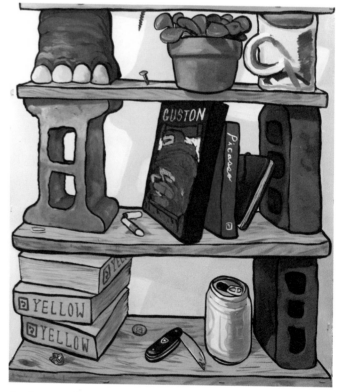

Bookcase with Pocket Knife, acrylic, by Harris Johnson

Yours, Mine, and Ours, gouache

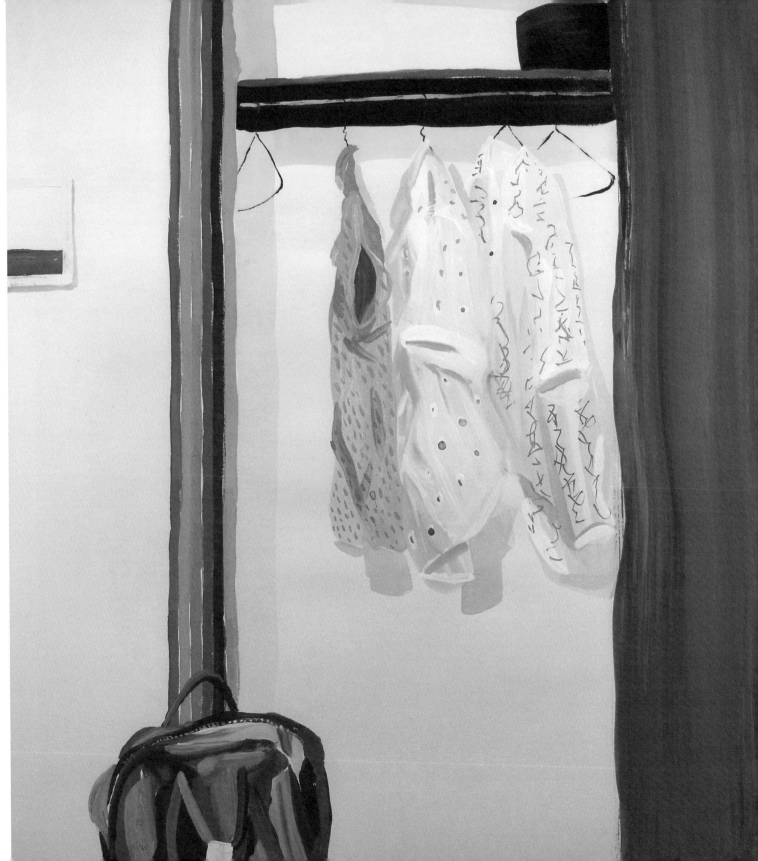

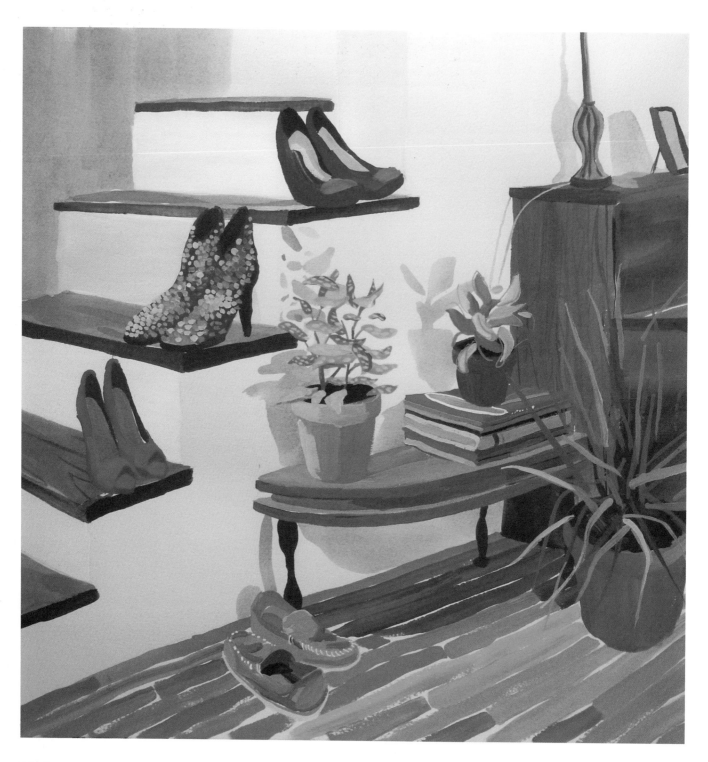

PORTRAIT STILL LIFE
DAY 12

Using someone else's objects can be an interesting way to approach a still life, almost like an exercise in portraiture; you can arrange the belongings in a manner that describes an event or your impression of this person. Objects like clothing, chairs, shoes, or hats have qualities that refer to the body and possess sentiment and character that may suggest the attributes of a particular person.

For this painting, I was looking at shoes casually descending a staircase. Whenever my partner and I go out for the evening, the ritual of choosing the right shoes to go with her dress is always a topic of conversation. I didn't do much in terms of arranging the shoes, but simply added a few more pairs and shifted them to imply movement up or down the staircase. My intent was to suggest the decision-making process that comes with getting dressed up to go out for the evening.

EXERCISE 12

You can borrow these objects from someone close to you or simply respond to an arrangement of someone's belongings in your home or workspace.

VARIATION

An interesting variation on this exercise is to let someone else pick the objects for you. In Libby's painting, she is responding to her son's hand-painted cup and the dandelions he arranged in the cup. The painting, while expertly depicted, has a child-like feel to it. You begin to imagine who the child is or what he may look like.

Detail

Up the Stairs, gouache and ink

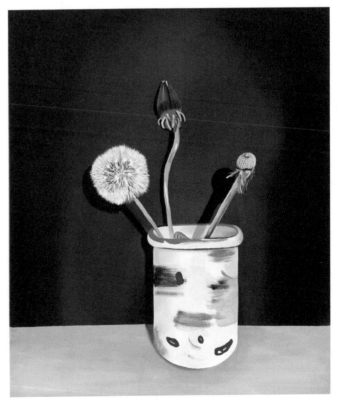

Jasper's Cup, oil, by Libby Black

ANTHOLOGY STILL LIFE
DAY 13

The things we collect tell a story about our lives. You can tell a lot about a person through the things he or she accumulates and displays, be they records, books, or movies. A record or book collection reveals a narrative of the person's influence and taste.

Music has always been an important part of my life and my studio practice. For this painting, I wanted to create a still life that could read as an anthology of influence in chronological order. I chose to work on a black ground to highlight the minimal details in text and color of the records' spines so that the viewer would literally read the painting from left to right.

EXERCISE 13

Choose an anthology or collection of things in your home to arrange into a still life, and then make a painting from it. It doesn't necessarily have to be books or records. It could simply be the dry goods in your pantry or the souvenir magnets on your refrigerator.

VARIATION

Another way to approach this theme is to use someone else's collection of objects. In Amy's painting *Cheap Date*, she was responding to her parents' collection of Harlequin Romance novels, focusing on the individual titles on the spines of the books.

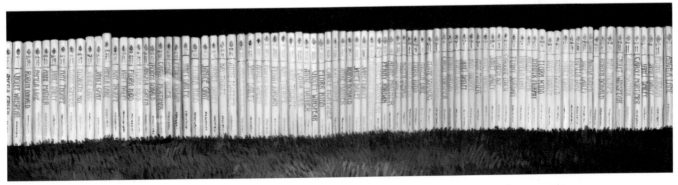

Teach Me to Dance, gouache

Cheap Date, acrylic and resin, by Amy Kligman

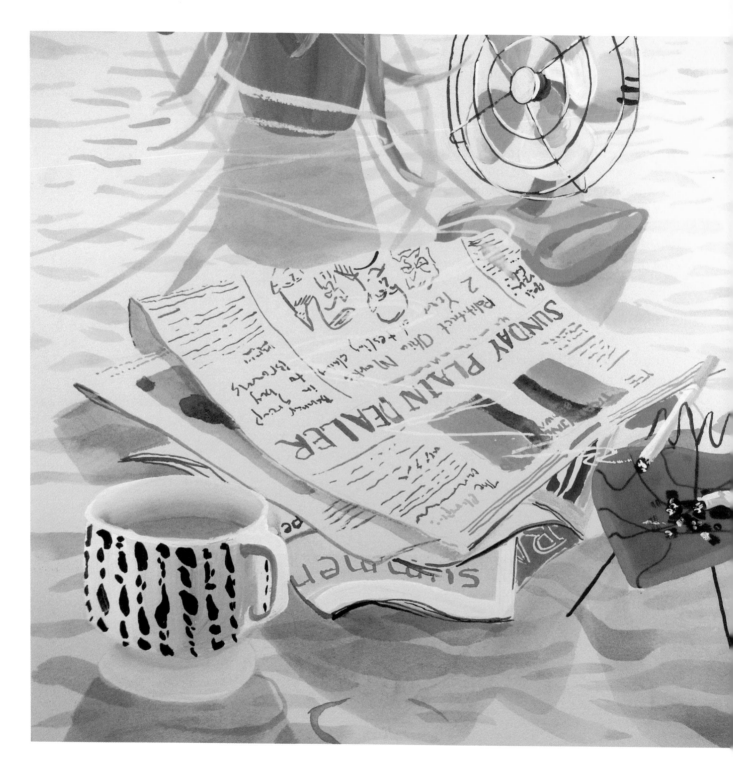

SUNDAY STILL LIFE
DAY 14

Sunday morning is one of my most enjoyable times of the week and an excellent subject for a still life. The challenge of suggesting a particular day and even time of day through still life can be inspiring in both universal and specific imagery. For this painting, I wanted to focus on my morning routine of reading the paper with coffee and cigarettes in the early morning light. I chose a topographical composition to suggest the particular vantage point of sitting and slowly waking.

EXERCISE 14

Choose a few objects that best represent your perfect routine on Sunday morning (or whatever day represents your most sacred moments of reflection). Arrange the objects to suggest the activity and place for this ritual.

VARIATION

A still life doesn't have to be still. For instance, Harris's painting of the interior of his car has a lot of activity and suggestion of movement. The ritual of driving to the studio while reflecting on last evening's work or anticipating a new idea can be an interesting variation on this theme.

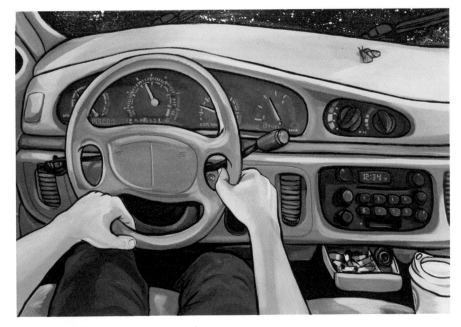

Preseason, gouache

Car with Moth, acrylic, by Harris Johnson

PART II: LANDSCAPE: PLACE

"I was never one to paint space, I paint air."
—Fairfield Porter

Plantscape, oil, by Cecelia Phillips

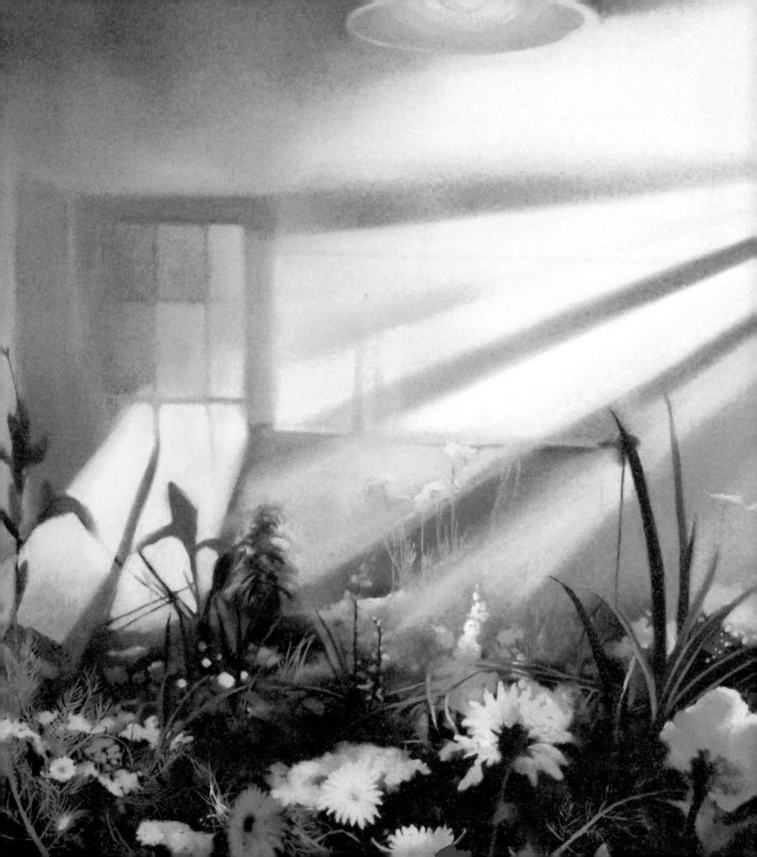

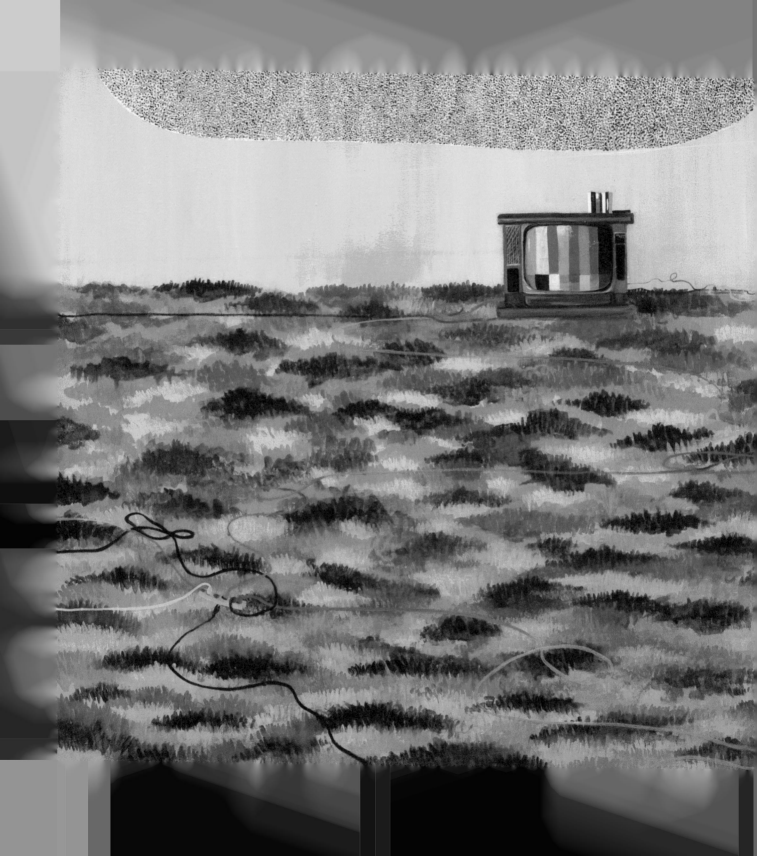

PRIVATE SPACES

Painting a landscape is essentially about representing space and the places that surround us. Landscapes are generally associated with sublime pastoral scenes, but as our landscape has dramatically changed over the past century, so have our ideas of what a painting about space can be.

The structure of foreground, middle ground, and background can be applied to almost any space. For instance, an interior space like your living room or studio can be a painting about space. As a painter, I use my local landscape as a subject to explore space and make paintings that are about the specific places I encounter every day. Therefore, I don't necessarily have to travel to the countryside to make beautiful paintings. I can simply sit in the backyard or take a walk through the neighborhood and respond to the places in my immediate environment. This next week's worth of exercises is devoted to using your home and neighborhood as inspiration to create paintings based on both the interior and exterior places you see every day.

Test Pattern, acrylic and resin,
by Amy Kligman

HOME LANDSCAPE
DAY 15

I have always been interested in painting space, and I've always painted pictures of the places where I have lived. I grew up in a rural environment; now that I live in an urban setting, my interest in space has not changed, but my paintings have.

Painting your home feels a lot like painting a self-portrait; there is a particular pride, or even vanity, that affects the decision-making and editing process. There is a very emotional response to that process of returning or leaving home. The first or last thing you see is the same every day, but your memory of it is constantly changing. For this painting, my intent was to paint the front of my home and suggest the beginning or end of this journey.

EXERCISE 15

Make a painting of the exterior of your home, whether it's where you currently live or perhaps your childhood home. Look for unique details and qualities of the space around your home to include in the painting. For example, in my painting I was interested in capturing the compressed nature of my neighborhood, so there isn't much open or negative space in the painting.

TIP

When working within a traditional landscape format with a distinct foreground, middle ground, and background, it's helpful to paint the background first and then work up to the foreground. Since painting is a medium that favors layers, this will help create a deeper space no matter how realistically you render the space.

The Skeleton Crew, gouache

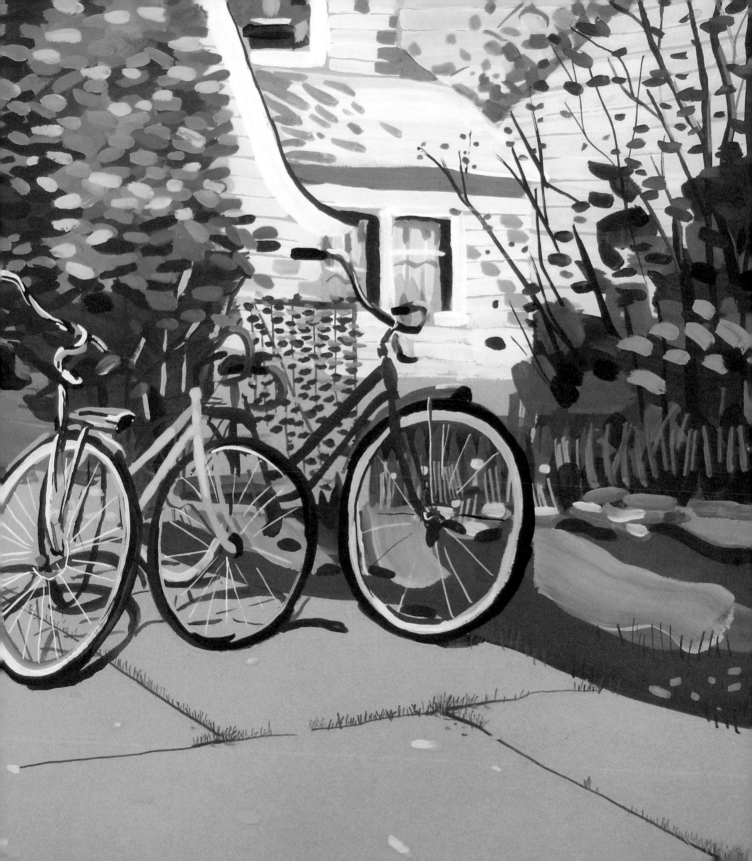

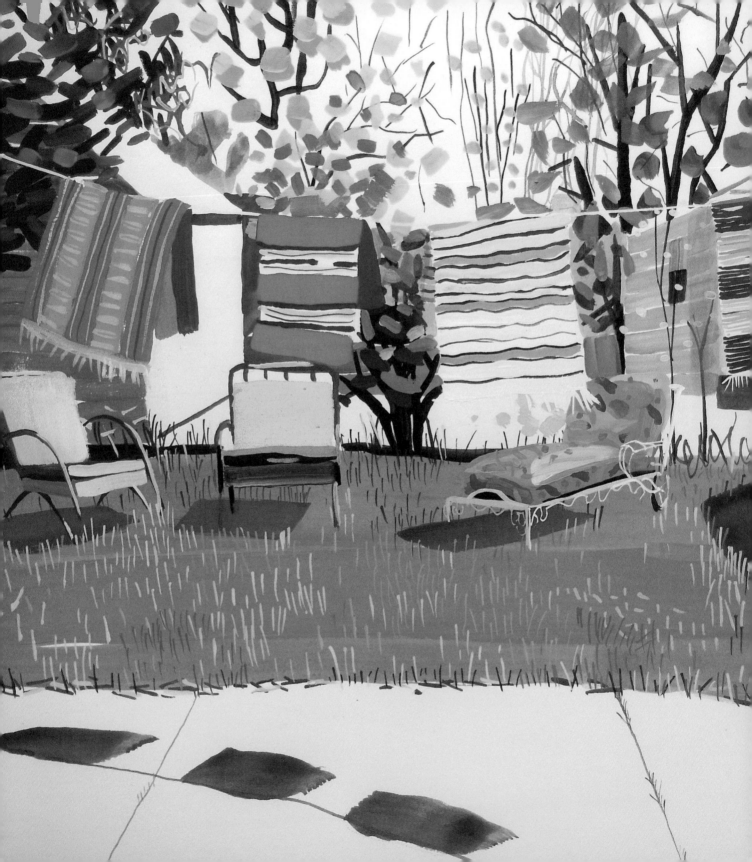

UTOPIAN LANDSCAPE
DAY 16

The backyard is a place of refuge and a great subject for a landscape; in the warmer months, it is the first place I retreat to after a long day of work. The backyard is also a space where a lot of activity happens—and unlike the front yard, the backyard is less formal. I spend a lot of time in my backyard sitting, reading, looking, and drawing; at times it feels like a second studio. For this painting, I wanted to document a moment between activities that suggests pause. The rugs drying on the line while the light rakes across the grass implies that silent reflection.

EXERCISE 16
Find a space in your backyard (or other exterior space that's like a little retreat for you) and make a painting from it. Focus on a particular time of day and its light quality to add to the mood of the space.

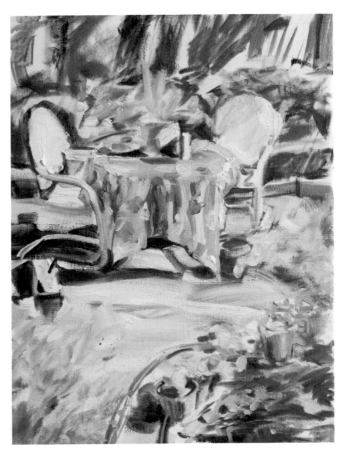

Backyard, oil, by Matthew Johnson

VARIATION

The size of your backyard doesn't matter. It could simply be the fire escape of an apartment or another transitional space from interior to exterior. Matthew painted a very intimate space behind his apartment in New York City.

North Shore Carpet Beaters Union, gouache

LIVING ROOM
DAY 17

Whenever I approach an interior space in a painting, I like to treat it as I would a landscape. An interior space is much shallower than an exterior space, and it can be a challenge to extend the space past the confines of walls. Including doors and windows in the painting can help give the sensation of deeper space. In this painting of my living room, the real subject is the exterior light pouring into the room, bouncing off mirrors, and wrapping around the architecture and objects. I wanted the emphasis to be on how the light changed the colors of the floorboards and created interesting patterns.

EXERCISE 17

Choose a corner of your living room that would make a good subject for a painting of interior space. Look for a view that includes a window—or maybe a door that leads into a second room or an exterior space.

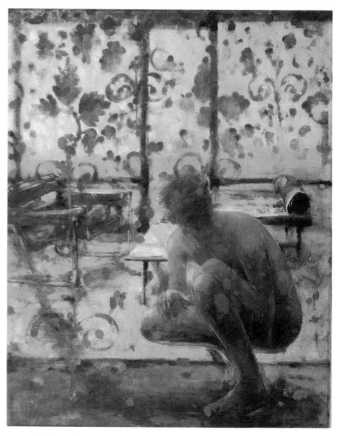

Moonlight Mile, oil, by William Newhouse

VARIATION

An interior space can also have a much more compressed space, and can focus on a particular detail that suggests space rather than shows a literal translation. In William's painting, he presents us with a figure, but the feature of the painting is the pattern of the wallpaper and subtle suggestions of interior space.

Mid Day, gouache

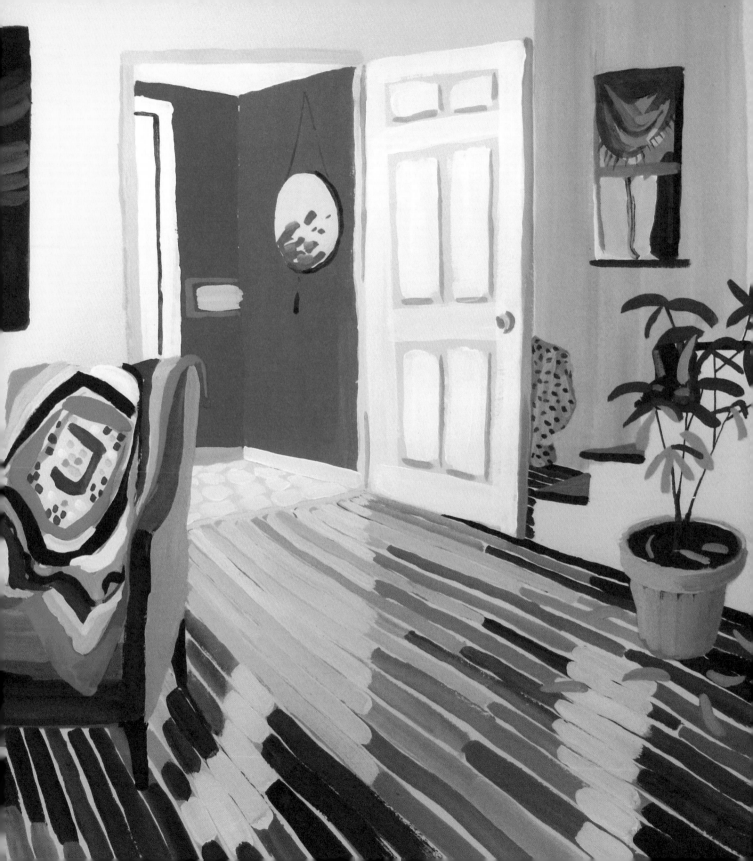

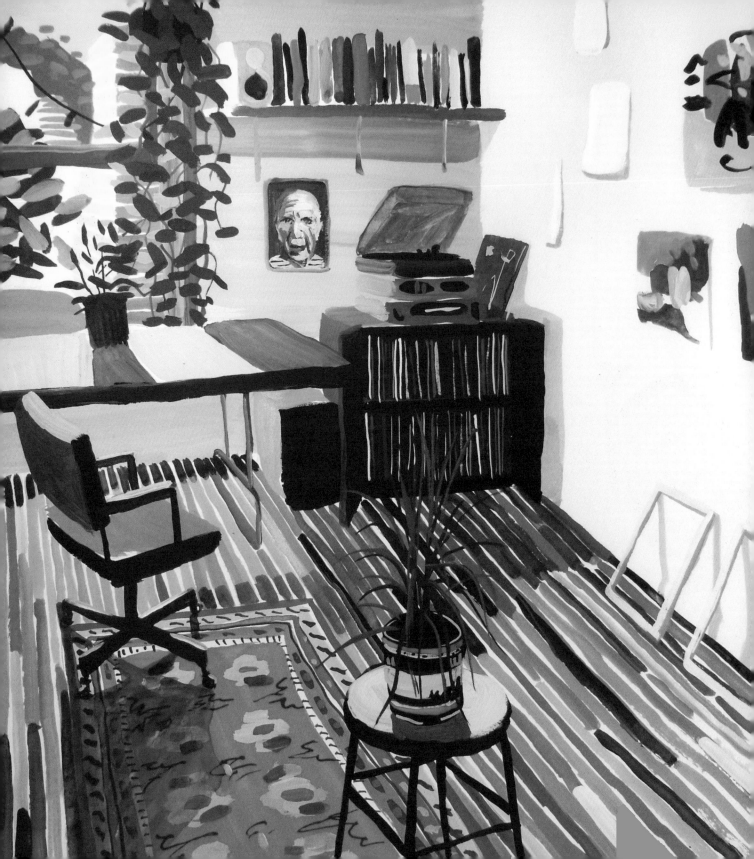

STUDIO SPACE
DAY 18

The studio is a place where I spend a lot of time and return to frequently as a subject of interior space. Throughout the twentieth century, painters from Matisse to David Hockney have been depicting their workspaces. For this painting, I wanted to reference that lineage and include my bookshelf as well as a little portrait of Picasso that hangs above my stereo.

An interior space can sometimes simply be defined by the three interlocking rectangles of the corner of a room. I wanted to repeat this rectangle motif in the rest of the painting to refer back to the structure of the interior space and the rectilinear form of painting itself. For that reason, I chose to repeat a lot of rectilinear shapes throughout the space.

EXERCISE 18

Choose a view of your workspace, and look for shapes that repeat in the space. They could be the shapes of in-progress paintings or maybe even your tools.

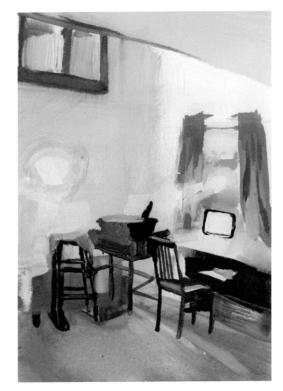

Studio Space, gouache and acrylic, by Cecelia Phillips

VARIATION

The studio is a sacred space for the artist, and that's probably why it's such a popular motif. In Cecelia's painting of her studio, she chose to emphasize the element of light flooding the room. Many artists choose their studios based purely on how much daylight the space receives. An interesting variation of this exercise could be to make a painting of your studio and depict how the light informs the space.

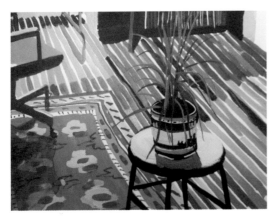

Detail

Little Room, gouache

KITCHEN
DAY 19

The kitchen is my favorite space in my home. It's usually where I begin and end my day, and it is the room with the most amount of activity. I eat, cook, read, and sketch in the kitchen. It's also the space where I have a lot of conversations, whether with visitors or over the phone. I wanted to make a painting of my view from the kitchen table and give the viewer the sensation of sitting from my vantage point. When working with interior space, it's sometimes necessary to bend the rules of linear perspective to give the viewer the sense of the entire space. In order to include the kitchen table and create the depth of field I wanted, I chose to make the objects abnormally large and intensify their colors to deepen the space. Adding a small still-life element to a painting that is primarily about space is a device that will draw the viewer into the space in a much more intimate way.

EXERCISE 19

Make a painting of your kitchen or your favorite interior space in your home. Emphasize the point of view of the room and include an extreme close-up of a foreground element to intensify the depth of field.

TIP

Often interior spaces have a lot of diagonal lines and dynamic angles. Use these elements to reinforce how you want the viewer to move through the composition. For example, in my painting of my kitchen, the diagonal lines that are emphasized in the painting encourage the viewer to zigzag through the space. They eventually lead the viewer's eye to the top of the painting and into another room in the background.

Kitchen, gouache

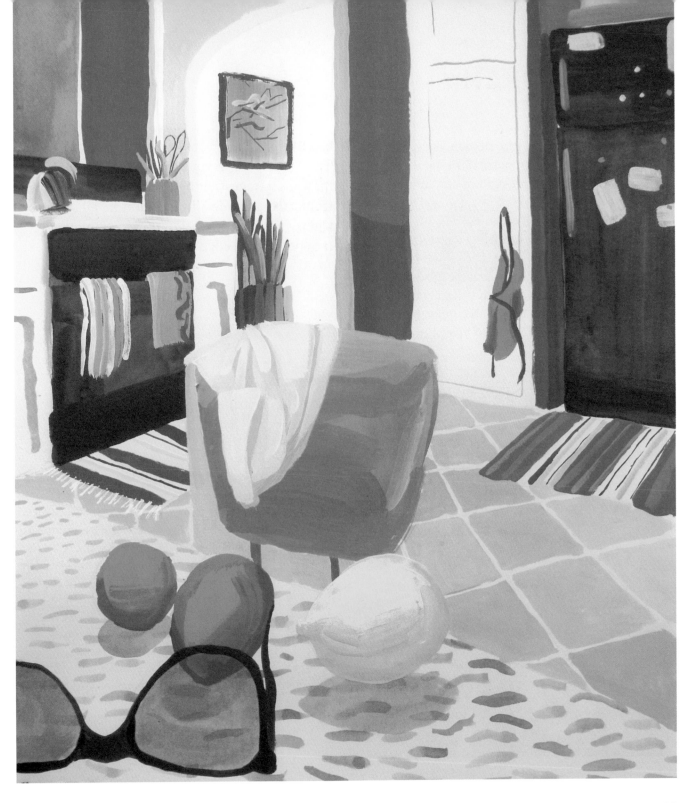

PORCH
DAY 20

A porch or similar hybrid space straddling both interior and exterior offers countless possibilities for a landscape. The challenge here is to represent two very different types of spaces seamlessly. For this painting, I was looking from the porch through a handmade birdhouse to the landscape beyond, so essentially I was trying to capture three distinct areas of space. The subject of the painting is clearly the birdhouse, but the inclusion of the subtle details of the handrailing and post in the foreground makes the viewer aware of the vantage point and conscious of the interior-like feel of his or her own position in the scene.

EXERCISE 20

Choose a space in your home, like a porch or maybe a garage, that has both interior and exterior space. Include a foreground detail somewhere in the composition that is dramatically cropped by the edge of the painting.

TIP

When painting this space, remember to apply the rules of atmospheric perspective and use more neutral tones and muted colors in the background and through the middle ground. Increase the contrast and use more saturated colors in the foreground. This will give the illusion of a deeper space and push the foreground elements forward.

Complementary colors are a good way to create high contrast, and the neutral colors they make when mixed together will create low contrast to use in the background.

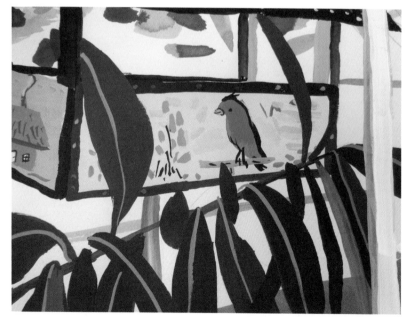

Detail

Old Maker, gouache

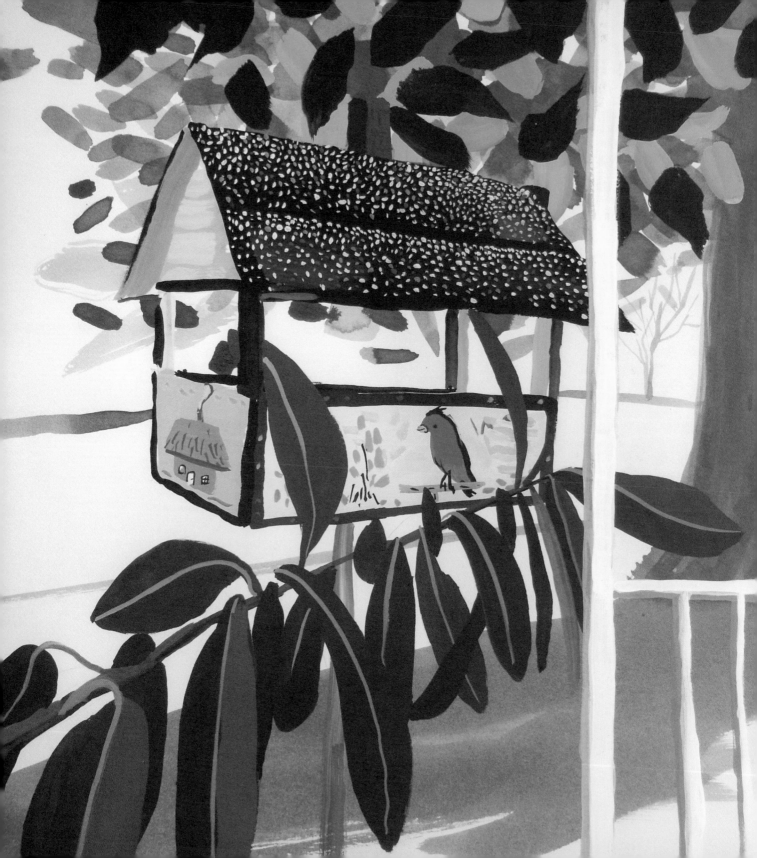

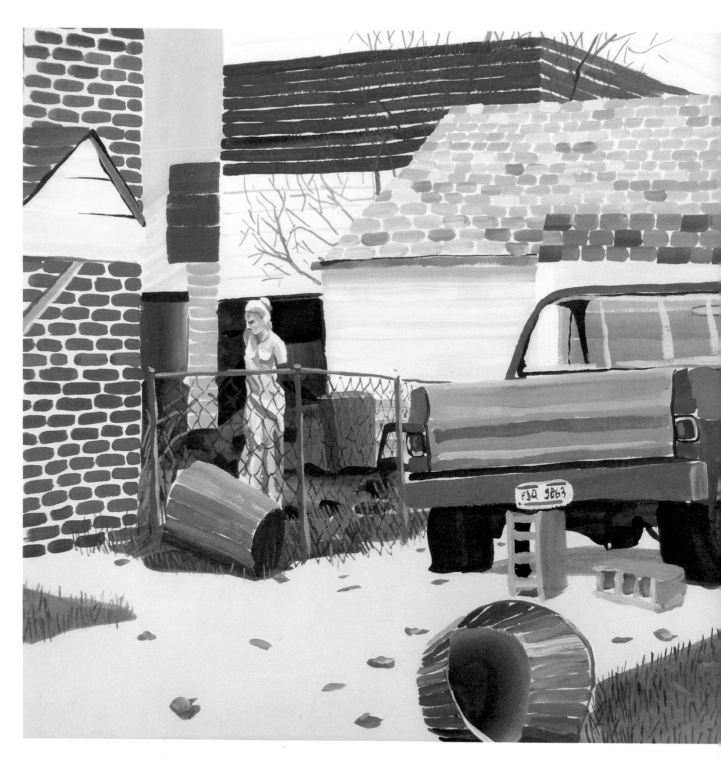

NEIGHBORHOOD WALK
DAY 21

When I am moving through spaces familiar or unfamiliar, I get a lot of ideas about painting. Whether I'm in the car, on my bike, or on foot, the sensation of scenes moving past me at variable speeds always inspires new painting ideas. Walking through your neighborhood is an intimate process that suggests both private and public space. For this painting, I was looking into my neighbor's backyard one day while I was out for a walk, and I was fixated on the juxtaposition of their classical female statue next to a very masculine pickup truck that hadn't been moved in quite some time. The textures of the two objects appeared connected, and yet completely different in a charming, contradictory fashion. I took a few photographs of the backyard and did a few quick thumbnail sketches in my sketchbook to use as reference when I got back to my studio later that day. The painting is a combination of the photographs, my sketches, and my memory of the scene.

EXERCISE 21

Talk a walk through your neighborhood, looking for a space other than your own that inspires you for some reason. Do a quick sketch of the space, take a few reference photos to work from, and make a painting of the space.

Greener Grass, acrylic and resin, by Amy Kligman

VARIATION

It's an interesting transition when we begin to travel outside the comfort of our home and studio to look for inspiration in the real world that surrounds us. It's a bit voyeuristic and scary at first. Amy addresses this emotion quite exceptionally in her painting *Greener Grass*. She presents us with a view looking right over the fence and into a completely different space. It asks the question, "Is the grass really greener?"

TIP

Whenever I leave the house, whether I'm searching for an idea for a painting or not, I always travel with a little sketchbook and a small point-and-shoot camera, both of which can fit in my pocket. You never know when something will inspire you to make a painting, so being prepared to take the proper notes and reference photographs is crucial to the process.

My Street Fighting Man, gouache

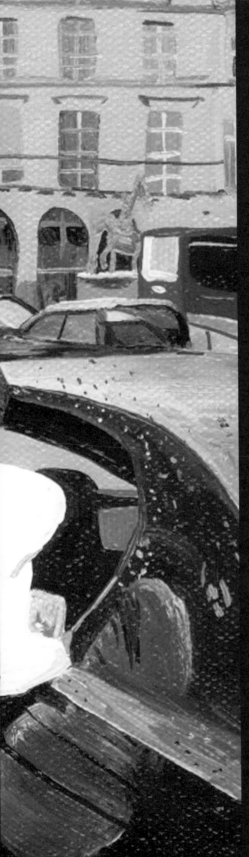

CHAPTER 5

PUBLIC PLACES

In the preceding chapter, we found that a landscape isn't limited to exterior space or sublime scenes of the horizon or trees. The landscape and places we see in a typical day of commuting through our local environment are splendid subjects for a painting. The public spaces that we frequently encounter are important to our personal narrative, and the documentation of these places—no matter how seemingly mundane—elevates their unique qualities when painted with careful observation. The public space comes with a different set of challenges than the private space of your home.

Photography, a sketchbook, memory, and invention are necessary tools. While you can certainly make these paintings from observation with a portable easel, the obstacles in some spaces, depending on their traffic, can be difficult. You may want to try working both with an easel and without. These next seven exercises are devoted to making paintings that explore public space, from the places you frequent regularly.

Danielle Steel and Her Daughter,
oil, by Libby Black

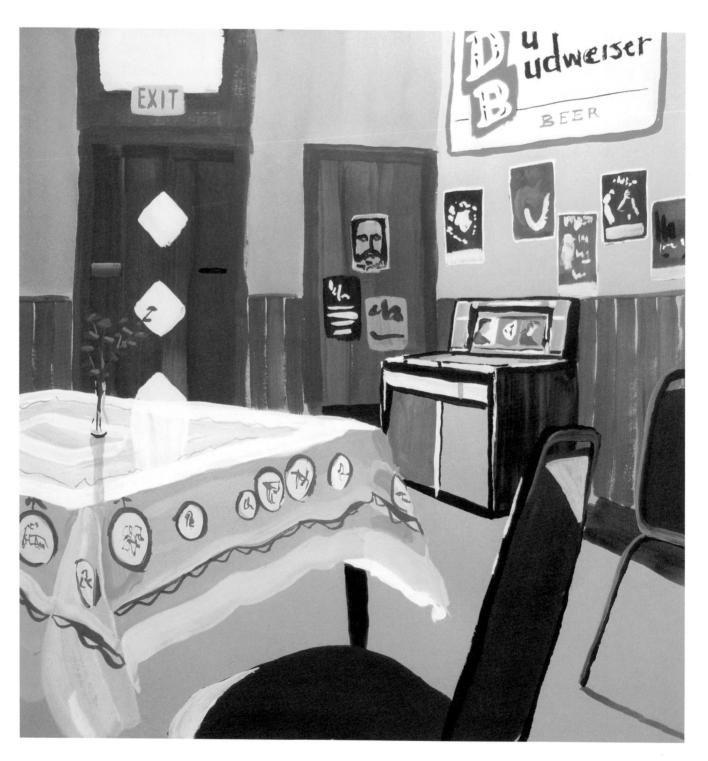

CAFÉ
DAY 22

The casual setting of your favorite café or place for brunch is a good subject to begin with, especially if it's a place you go frequently. You'll be able to rely on memory a lot more than you would with a less-familiar place. There is a long tradition of artists painting the gathering places of their neighborhoods. Think of van Gogh's paintings of cafés or Edward Hopper's iconic paintings of diners. There is a certain energy in these places that continues to inspire artists.

This painting began as a drawing in my sketchbook. It's the interior of a music venue in my neighborhood that hosts a brunch on Sunday afternoons. I'm always startled by how different it looks on a sunny morning long after the bands have left town and the debris is swept from the floors. I sketched the scene, then returned and photographed the exact space from my sketch.

Whenever I have a photograph for a reference, I find it's helpful to limit myself by only using it for the first thirty minutes of the painting. At some point during the painting, abandoning the photography forces you to rely on memory and allows you to invent new moments. This makes the overall process more enjoyable and the painting more successful.

Detail

Detail

EXERCISE 22
Go to you favorite café or coffee shop and look for a space where you have sat many times before. Begin with a few sketches of that space and take a few reference photographs as well.

TIP

If you choose to work from a photographic resource, try to limit the time you use or look at the photograph back in your studio. You will be surprised at how much you can rely simply on your memory or invention to finish the painting. Regarding this issue of invention and working from memory, sometimes it is not about what you add to the painting, but what you edit from the image. For example, in this painting, the real-life table in the foreground had a lot of clutter, but I chose to edit that out to focus on the light pouring over the table instead.

September Morning, gouache

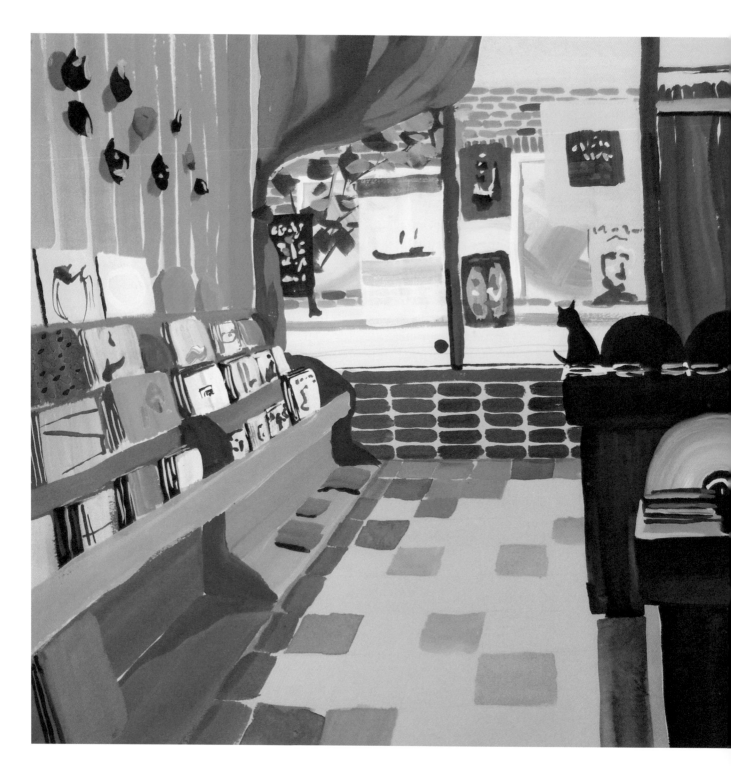

SHOP
DAY 23

One of my favorite hobbies is collecting records. Buying new and used vinyl is a routine I treat myself to every other payday. Fortunately, I live in a neighborhood where there are many independent record stores to choose from. For this painting, I chose one of my favorite record stores, located in a cozy storefront attached to a house. I wanted to capture the long row of records on the left wall and the space outside and across the street. I did a few drawings in my sketchbook and took some photographs to work from, then went back to my studio to start the painting. I wasn't concerned with the individual details of the records or posters, and many of the marks that suggest text and pictures were both invented and done from memory.

EXERCISE 23

Choose a shop in your neighborhood that you often patronize and make a painting from it. Ask the shopkeeper if it's okay to sketch and take photographs of the store to use as a reference from which to make a painting.

Detail

VARIATION

The storefront is a perfect example of how our landscape has changed dramatically over the past century. An interesting variation on this exercise could be to paint the exterior of your favorite store. In Libby's painting of a Louis Vuitton storefront, the exterior of the building fills the entire canvas, denying us any sense of atmosphere or horizon.

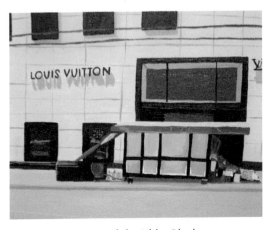

Louis Vuitton Store, oil, by Libby Black

Pay Day, gouache

NIGHT PAINTING
DAY 24

Night paintings are an exciting variation on the land-scape. Night space is much flatter than day space but can create interesting moments for abstraction, especially in an urban environment with a lot of artificial light. When I deal with the subject of nighttime, I like to use a black ground. For this painting, I was looking at the gas station around the corner from my house. I was especially inter-ested in emphasizing the weeds in the foreground inter-rupting the artificial glow of the lights. The gas station is an iconic subject in American landscape painting; it's a place that suggests movement and transit.

At night the stillness and illumination of this ubiqui-tous structure can be very dramatic and poetic.

EXERCISE 24

Choose a structure or place that is illuminated by artificial light to make a night painting. Work on a black piece of paper or canvas, or simply paint your ground with a dark color.

TIP

Working on a black piece of paper can be challeng-ing, like the reverse challenges of watercolor painting where the white ground is your source of light. When you're working on a black ground, you're adding the light and allowing the dark areas to remain untouched. Make sure to do the necessary prepara-tory drawing so that you know where, exactly, you're adding the color and light.

Black Gold, gouache

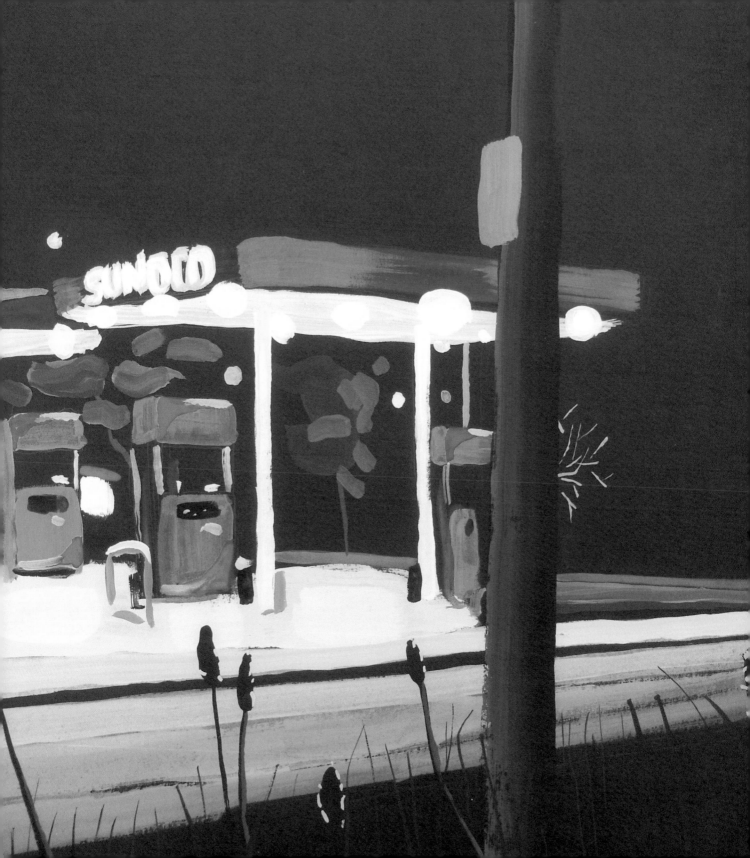

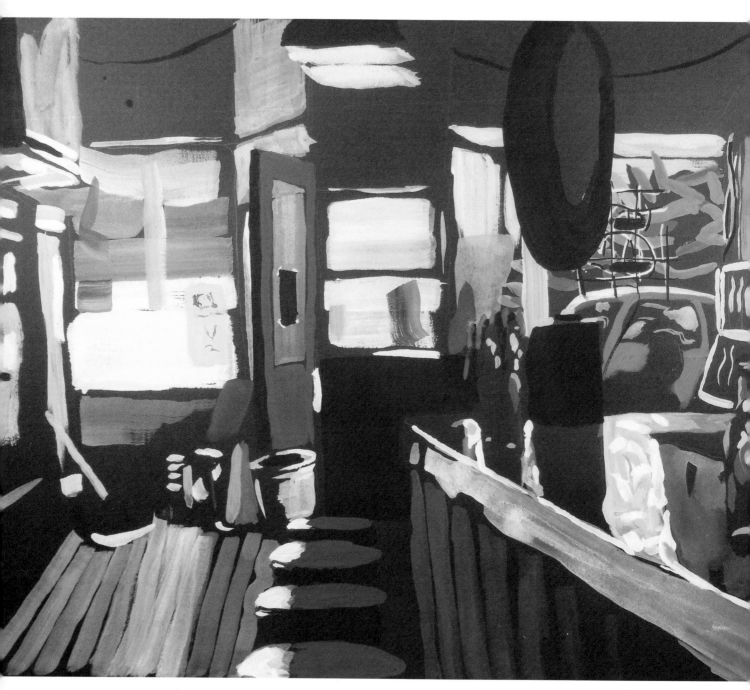

Early Spring, gouache

HAPPY HOUR
DAY 25

Using a black ground for an interior space can also be an effective way to deal with how light informs a space. We usually think of bars and taverns as being dark places that are dimly lit, but there is something really beautiful about how the last hours of daylight pour into a window of a dark bar and increase the contrast and color of the space and objects. For this painting, I was sitting at the bar in one of my favorite taverns and looking directly out the front window—observing the light cascading across the floor, stools, and bar. I took a few reference photographs and did a very detailed drawing of the space while I finished my beer before I returned to the studio to finish the painting. The light made for a lot of interesting shapes and colors as it bounced off mirrors and different-colored glass.

The hours between 4 p.m. and 6 p.m., "happy hour," are a great time to explore light and space in a public place. There is a sense of the day coming to a close and the anticipation of night beginning that can be sensed and translated into a picture.

EXERCISE 25

Go to your favorite tavern or bar or some other transitional gathering place where the light pouring through the window is a character in the space. Make a painting that sums up this part of the day.

VARIATION

Artificial light—like the neon signs typically seen in bars—is a great painting subject. It's challenging to create that glow and depict how it interacts with the space of night. In Cecelia's painting of a bar in Texas, she expertly depicts this with a very loose and painterly mark and by allowing the colors to bleed into one another while they are wet—a technique you can achieve if you work quickly.

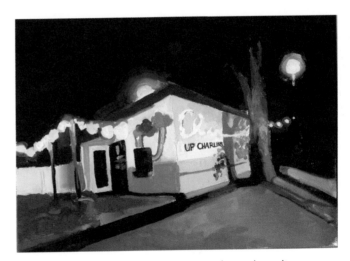

Cheer Up Charlie's, Austin, Texas, gouache and acrylic, by Cecelia Phillips

BARBERSHOP
DAY 26

The window is an important motif in my paintings about public places. I have always enjoyed the compression of interior and exterior space that you get when you suggest the structure of the window in the composition. This type of composition presents a lot of opportunities for playing with depth of field based on how you use contrast and value. For this painting, I was sitting in my local barbershop waiting to get my hair cut and sketching the street and the windowsill. After my haircut, I took a few reference photographs and returned to my studio to make a painting. I chose to work on a background for this painting that emphasized the interior/exterior aspect of the composition and increased the richness of the wood paneling.

The barbershop or hair salon is another classic American subject. There is a communal spirit to these utilitarian public places that suggests new beginnings and is very universal.

EXERCISE 26

The next time you're waiting to get your hair cut, bring your sketchbook and camera. Make some drawings and notations of an interesting view of the interior space, and use them to make a painting.

TIP

When dealing with space in your paintings—especially interior space or forms that are man-made, like architecture—it's helpful to think about the direction of your brushstroke. Rather than filling in the space arbitrarily, push or pull the paint in the most logical direction the space is moving. For example, in my painting of the barbershop, the brushstrokes used to render the wood paneling are vertical, but when I'm describing the plane underneath the window, I use a diagonal brushstroke that corresponds with the linear perspective of the space.

Willy's, gouache

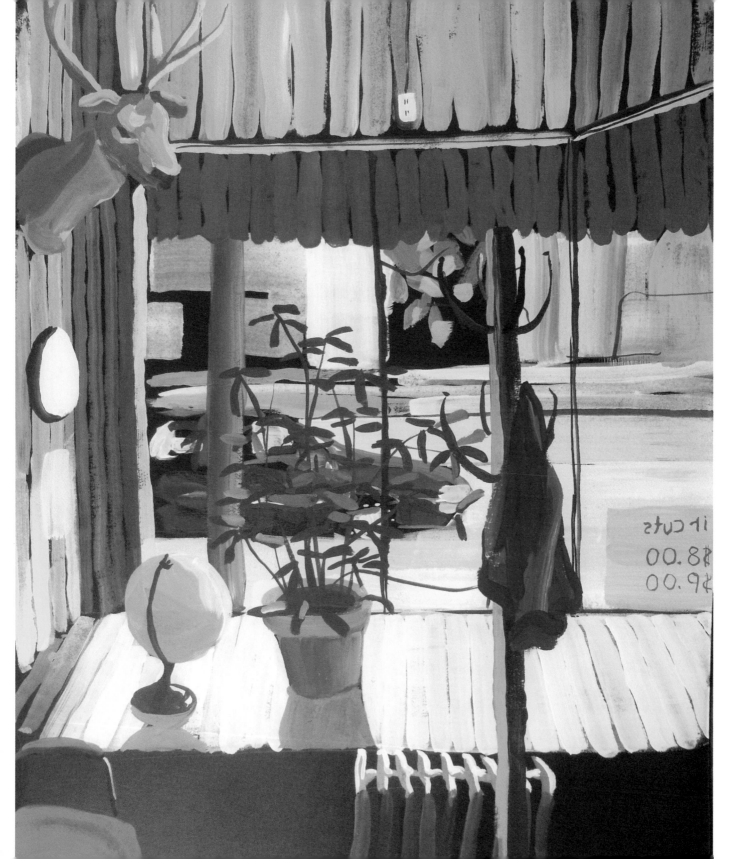

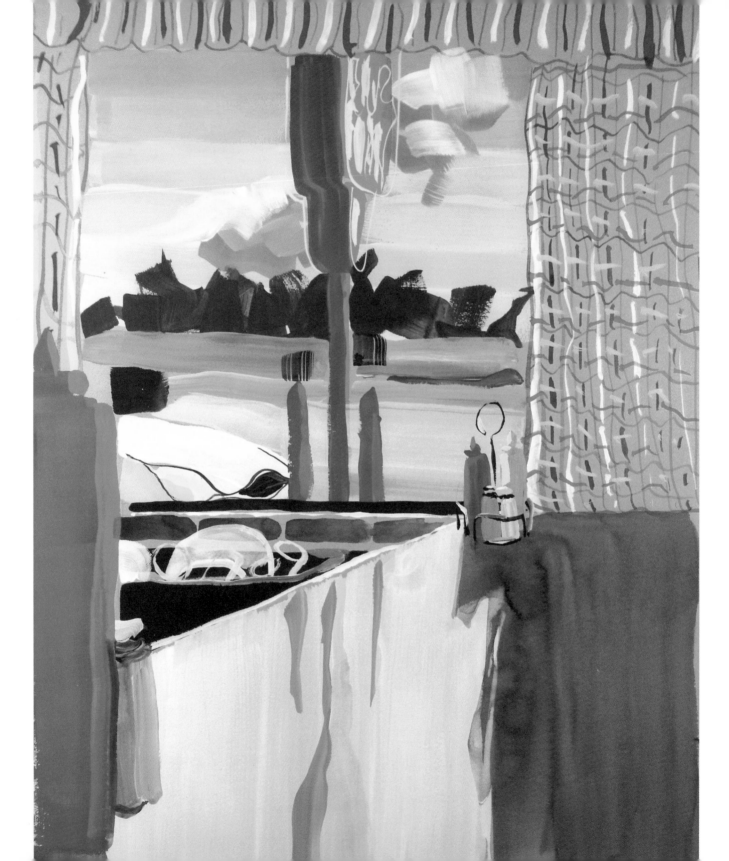

DINER
DAY 27

One of my earliest memories as a young artist was discovering the work of Edward Hopper and, more specifically, seeing *Nighthawks* for the first time. Since then, the diner has been a subject I have returned to frequently over the years. Like your local tavern, café, or barbershop, the diner is an iconic and universal public place that has so much potential for various compositions to describe its particulars. For this painting, I was sitting at the counter of a roadside diner just outside my hometown. I wanted to incorporate a small still-life motif that would emphasize the depth of field of the counter and lead the viewer to the exterior space and horizon.

EXERCISE 27
Go to your favorite diner and take a sketchbook and camera with you. Look for unique details in the diner or find a view that incorporates both the interior and exterior space.

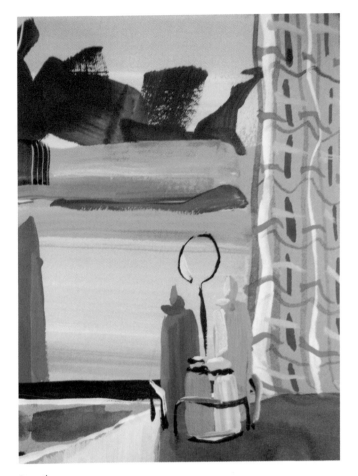

Detail

TIP

When considering all the different types of surfaces and textures in a particular space, vary the amount of paint you use to render different types of surfaces. In my painting of the diner, I used very transparent washes to articulate the light across the counter. I chose to use thicker paint to render objects like the ketchup and mustard bottles because they have a different surface.

Catsup, gouache

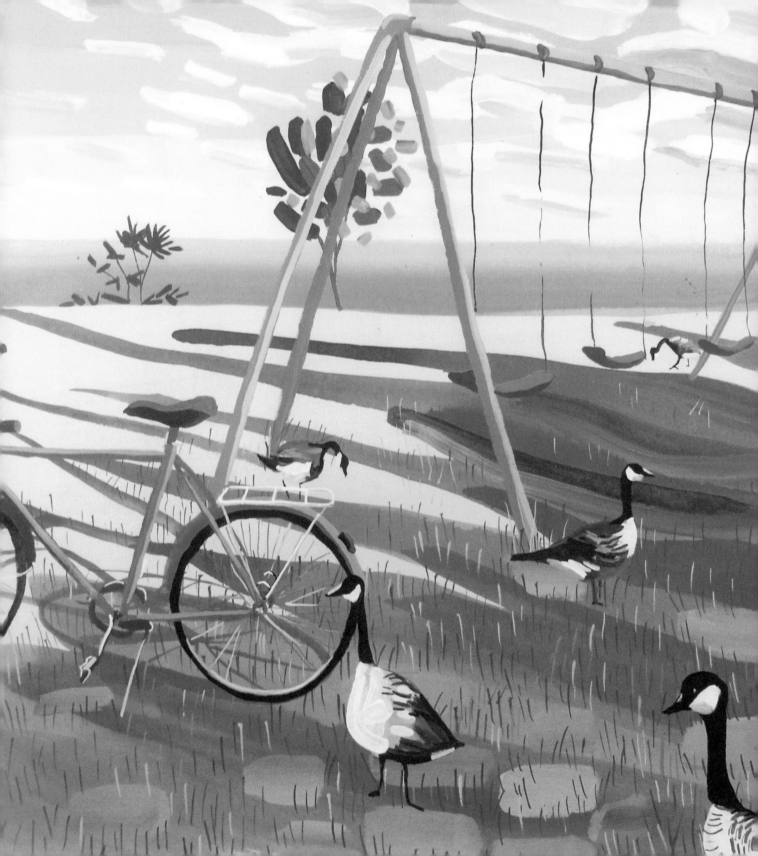

PARK
DAY 28

I often go to the public parks in my neighborhood to draw, think, and research painting ideas. The park at the end of my street also happens to be at the edge of Lake Erie and is a great place to work. For this painting, I wanted to begin with a landscape that had a traditional landscape format with a dramatic horizon. Most of the painting was done from observation. It was a very simple composition that used my bike and the swing set to break up the transitions from foreground to middle ground. When I was packing up to return to the studio, a few geese walked by. When I got back to the studio, I started painting in the geese from some stock photography, carefully adjusting the scale and placement to reinforce the movement through the space.

EXERCISE 28

For this last painting about space, take a trip to your nearest public park to make a painting. Begin the painting on-site and finish it in your studio, adding elements from memory or perhaps invention that reinforces the spatial elements of the painting.

VARIATION

Depending on how much time you spend in the park and working from observation, you may want to let some of the space be an invention from your imagination. In Amy's painting, the surreal horizon at the edge of the playground is an element that is invented rather than observed, but it adds a magical atmosphere to this particular painting.

Detail

Beach Club, gouache

Somewhere Special, acrylic and resin, by Amy Kligman

PART III: PORTRAITURE: PERSON

"I do not pose my sitters. I do not deliberate and then concoct ... Before painting, when I talk to the person, they unconsciously assume their most characteristic pose, which in a way involves all their character and social standing—what the world has done to them and their retaliation."
—Alice Neel

Tim (Detail), oil, by Matthew Johnson

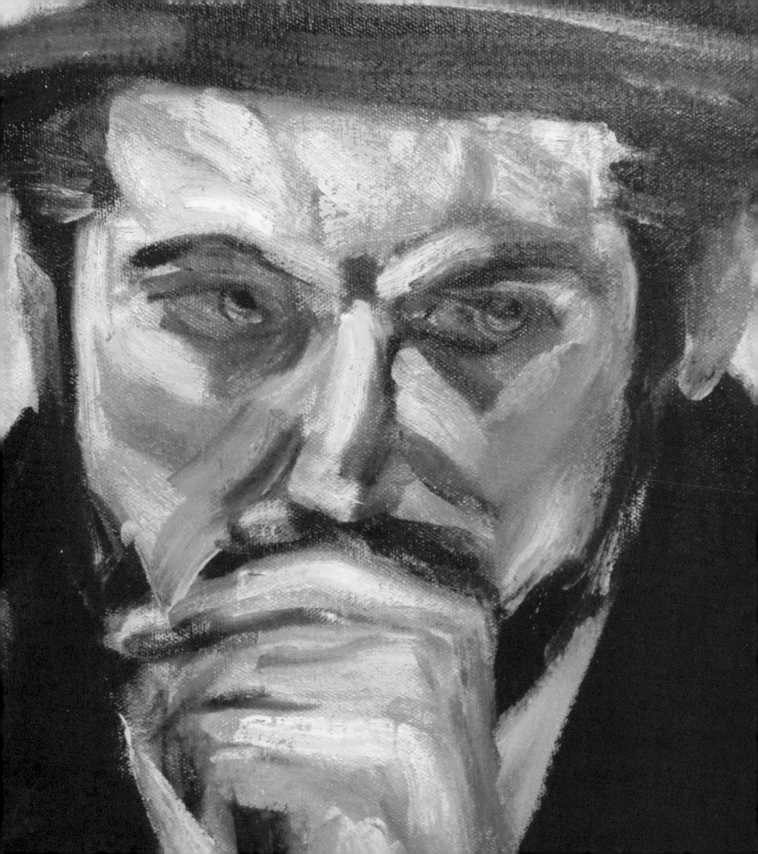

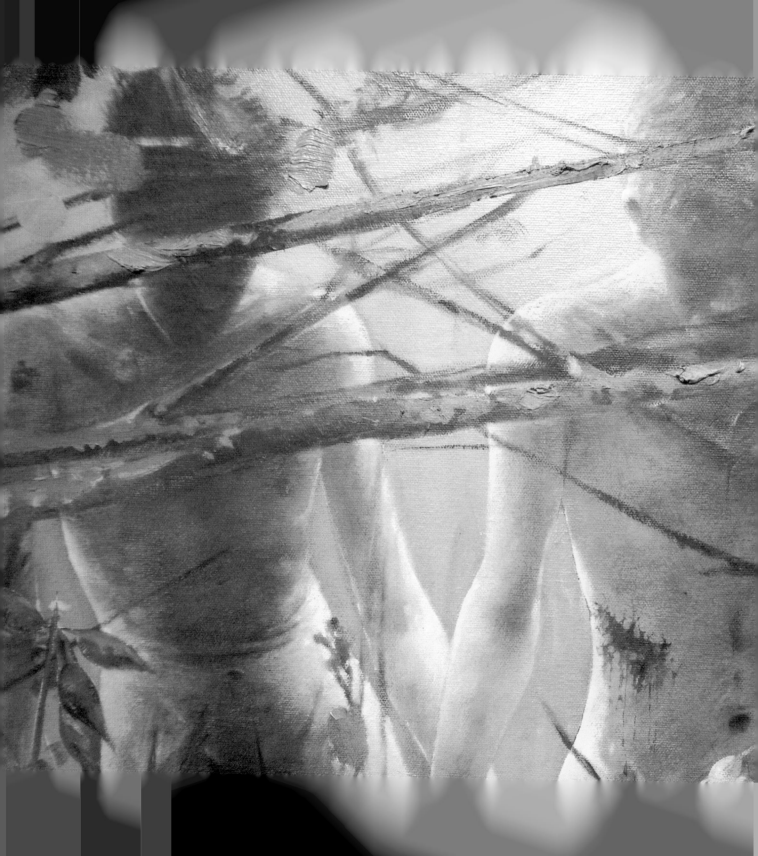

CHAPTER 6

INTIMATE TRADITIONS

Portrait painting is a very intimate and rewarding tradition for representational painters.

The intimacy of spending hours with someone examining his or her face, features, and posture can be a very stimulating process that often encourages great conversation. Painting someone's portrait is like meeting the person for the first time, no matter how long you may have known your subject. The challenge of creating an accurate likeness of the sitter is very rewarding and requires careful and deliberate observation.

When you begin to paint portraits, the first challenge is to find willing subjects to sit for you. You, your friends, and your family are a good place to start. Eventually broadening your scope to others in your social circle and even people you don't know intimately is a progression you want to build up to with time. The next seven exercises are about engaging the people who are closest to you—and whom you see frequently—to sit for portraits.

Safe Passage (detail), oil,
by William Newhouse

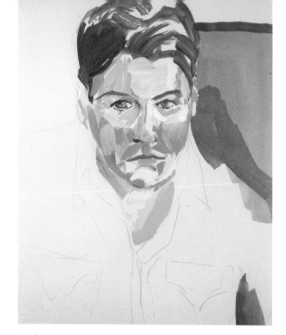

Mid-progress

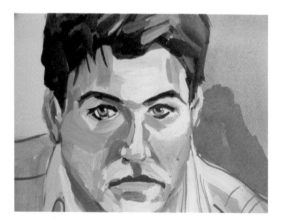

Detail

TIP

Since you're using a mirror for your self-portrait, you're looking at a reverse image. Use the mirror to your benefit and periodically turn the painting around and look at it in the mirror to check the accuracy of the symmetry in the face.

SELF-PORTRAIT
DAY 29

Like the still life, the self-portrait is a logical place to start when beginning to explore portraiture because of the familiarity of your own face and the fact that it's always there, right in front of you. A lot of painters return to the self-portrait periodically to document change; not only in appearance but also in formal and stylistic approaches. For this painting, I used a mirror and spent a few minutes doing a very loose contour drawing before I began painting. When I'm painting a face, I like to block in its planes with a big brush, focusing on the overall structure and volume of the head or skull before I begin to observe the particular features of the face.

EXERCISE 29

Find a mirror large enough to accommodate the type of self-portrait you want to make. Begin with a loose contour drawing, observing the gesture or posture you take for the portrait.

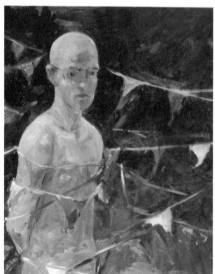

Self-Portrait with Flags, oil, by William Newhouse

VARIATION

A self-portrait certainly doesn't have to be done entirely from observation. You can add and even edit elements. Including a visual metaphor in the painting or suggesting some narrative can add to the portrait immensely. In William's self-portrait, the inclusion of the flags adds a whimsical quality to the painting.

Self-Portrait, gouache

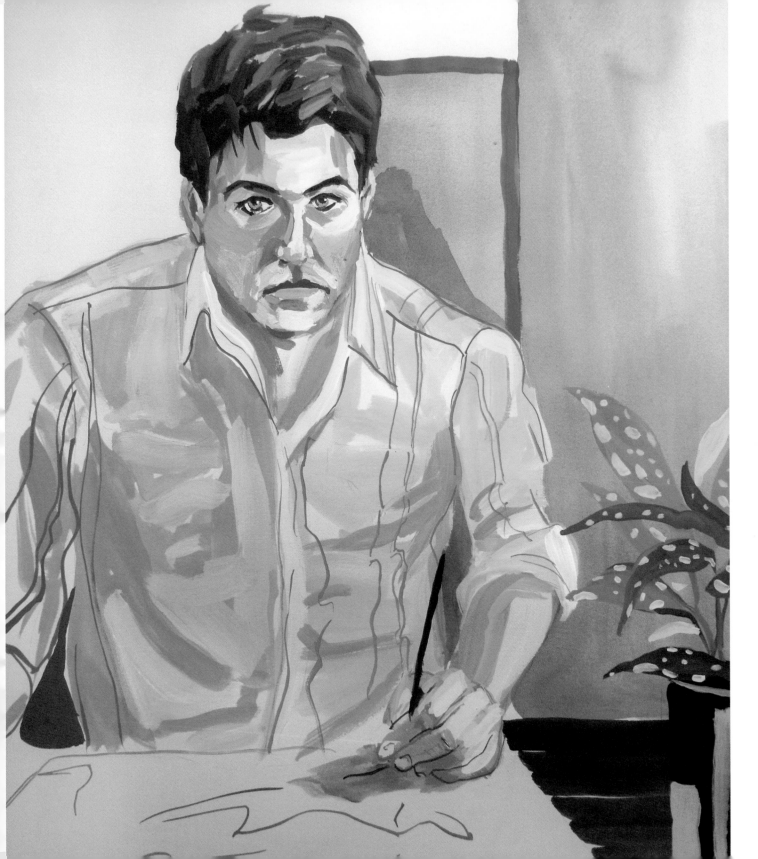

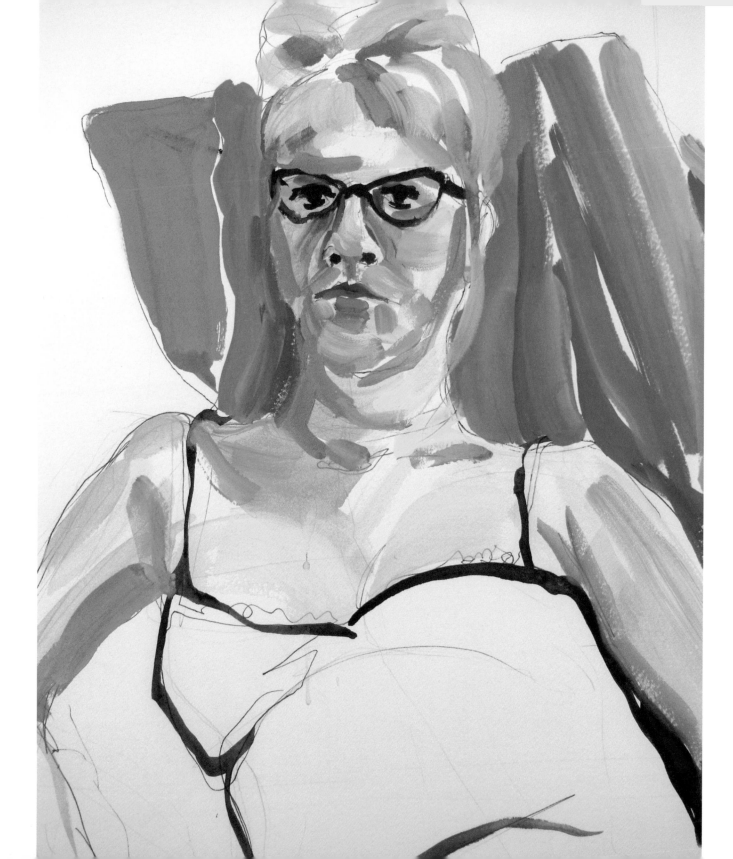

INTIMATE PORTRAIT
DAY 30

Painting a portrait of the person you see most often is another good way to begin. The benefit of this subject—whether it is your spouse, a best friend, or a family member—is the honesty he or she will share with you in regard to likeness. Allowing your subject to make decisions about location, posture, and attire can also contribute to the collaborative possibilities. For this work, I painted my partner and let her make a lot of the formal decisions about the look and mood of the portrait.

To prevent the color from becoming too monochromatic, it's helpful to begin a portrait with very saturated color rather than the neutral color of flesh tones. Use cool violets and blues for the shadows and warm yellows and oranges for the highlights. Even if you want a more realistic flesh tone for the portrait, taking risks with color at the beginning of the process will inform the layers that follow and make for a lively portrait.

EXERCISE 30

Ask someone to sit for you—preferably the person you see most often—to make a portrait. Discuss the pose and clothing as well as location. Allow your subject to be as involved in these decisions as you both feel comfortable with.

Mid-progress

Krista, acrylic and gouache

TIP

When painting a portrait from observation, it's important to take many breaks—especially in the beginning of the process—and step back a significant distance from the painting. When your subject takes breaks from sitting, use that time to look at the progress and let your subject look and comment as well.

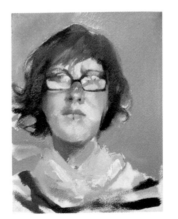

Ashley, oil,
by Cecelia Phillips

VARIATION

For this portrait, an interesting variation could be to paint a close friend, focusing only on the gaze. The classic bust composition is another good format when you first begin making portraits, because it isolates the subject's gaze. In Cecelia's painting of her friend Ashley, you are drawn into the painting through the sitter's intense gaze.

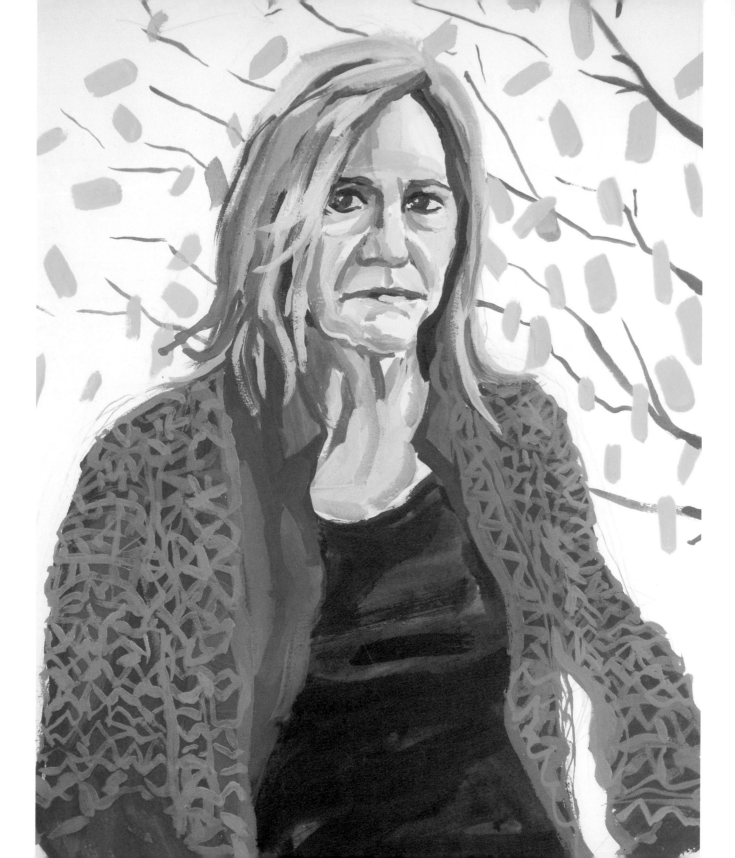

PEER PORTRAIT
DAY 31

The ritual of artists asking one another to sit for portraits is a familiar one for both the painter and the subject in this exercise. Your shared understanding of the process is beneficial when you first begin painting portraits. Whether the artist sitting for the portrait is a painter or not, there is a particular comfort in painting someone who is familiar with the creative process; the dialogue and feedback can be very valuable. For this portrait, I asked a colleague whom I have known since graduate school to sit for me. We are very familiar with each other's work, and even though she is an abstract painter, her comments during the process were very encouraging. I chose a traditional bust composition for this painting, including elements of the torso and arms. The orange knitted sweater became a very important element because it allowed me to follow the contours of her anatomy—and the mark making I used to create it served as a homage and "portrait" of her style of painting.

EXERCISE 31

Ask a fellow artist whose work you're familiar with to sit for a portrait. Look for details in his or her appearance or clothing that you can respond to and possibly translate into a painted element in the portrait.

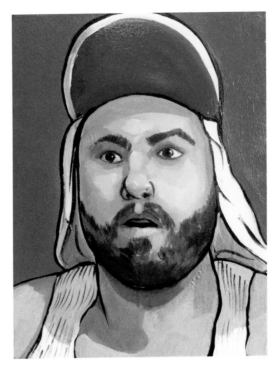

Aaron, acrylic, by Harris Johnson

Another nice thing about painting a portrait of a fellow artist is the person's comfort with having his or her image depicted. In Harris's painting of his studio neighbor, the great painter Aaron Kohen, you get a sense of the subject's comfort with posing and even his sense of humor.

TIP

I generally ask my subjects to wear something patterned when they sit for me. Getting the contours of the anatomy can be tricky with a clothed figure, but if the sitter is wearing something with a repeating motif, like stripes, you can employ the pattern to articulate the gesture and contours of his or her anatomy.

Ann, gouache

CASUAL PORTRAIT
DAY 32

One of the most challenging experiences of painting portraits is when you begin to paint people you don't see that often and aren't as familiar with. A casual acquaintance—perhaps someone whom you instantly recognize but don't know as well as a close friend or family member—is a perfect subject for this challenge. For this portrait, I asked the editor of this book to sit. We had spent time together in both social and work-related settings but had never spent an entire afternoon together.

Painting portraits can sometimes be awkward for both the subject and the artist; it's a very intimate setting where both participants are very aware of the process. Having sat for portraits myself, I know it's akin to an experience like going to the barber, and any good barber—or painter—knows that conversation is the key to putting your subject at ease.

Budgeting your time is crucial when painting portraits. For this painting, I spent only three hours with the subject. Much of that time was dedicated to the face and notations about posture, clothing, and background that I finished after she had left.

EXERCISE 32

Find someone in your larger social circle to sit for a portrait, whether it's an old friend you haven't seen in a while or maybe a coworker. Give yourself a time limit for how long you actually paint from observation.

TIP

If you choose to depict the background in your casual portrait, it's important to make notations throughout the process of painting the portrait so that the painting is unified. It can also be helpful to use colors similar to those you are using in the figure and incorporate them into the space. In my painting, I was responding to studies on the wall and incorporating the colors of the sitter's shirt into them.

Mary Ann, gouache

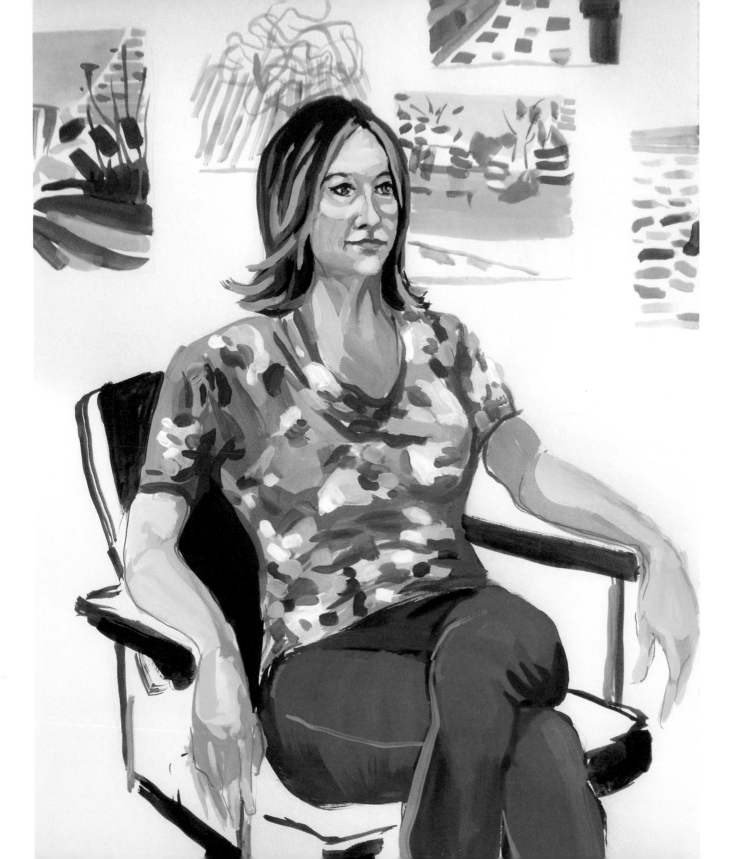

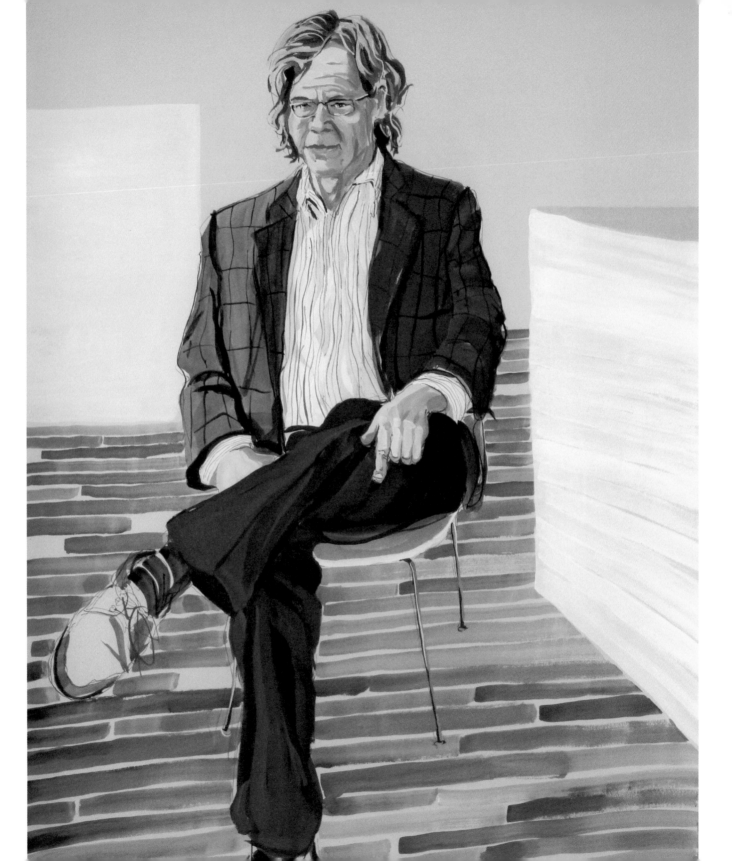

LOCATION PORTRAIT
DAY 33

Sometimes it is necessary to leave the studio for a portrait. Perhaps scheduling time for sittings is the obstacle, or maybe the environment or space needs to be a particular feature in the portrait. Whatever the reason, painting in an unfamiliar space can add to the portrait immensely. Consider the experience like you would a commission by traveling to the subject's preferred setting. This can enhance the process and add the right amount of "pressure" to get the likeness correct. For this portrait, I painted my art dealer in his gallery. I wanted to include details of the gallery in the painting, like the warm hardwood floors and clean white pedestals typically seen in an art gallery. With portraits, you often find that the space can affect the subject's posture and mood. If it is a space to which the sitter has a personal attachment, it will show in the portrait. This is a portrait of a very confident man who is proud of the gallery space he has created. While the painting reveals just minor details of what the space looks like, you can get a sense of the space from both his posture and his expression.

EXERCISE 33

Ask your subject to choose a location that best represents him or her. Once you arrive at the space, spend a significant amount of time sketching the place and talking to the person and encouraging him or her to pose.

TIP

Whenever I must bring painting supplies to a location, I like to travel as light as possible. So, instead of bringing an easel with me, I look for things at the location that I can use as a makeshift easel. Something you can find in a subject's home—anything from a folding chair to a stepladder—will work. Just make sure to always bring a drop cloth and tape.

Bill, gouache

VARIATION

An interesting variation on this theme could be to find a space that affects how the light informs the subject. In Matthew's painting, we are drawn into the portrait by the moody, suggestive light that surrounds the figure—almost as though the subject is emerging from shadow and light.

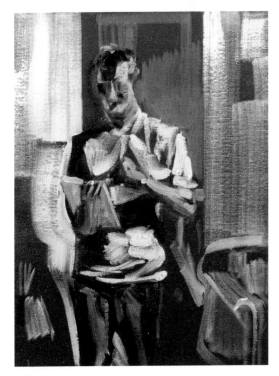

Untitled, oil, by Matthew Johnson

RELATIVE PORTRAIT
DAY 34

The family portrait is probably the most recognizable form of portraiture in much of the Western world. Our homes are full of portraits, whether they are paintings, professional photographs, or snapshots from a family album. If you look at any portrait painter's body of work, chances are you will come across portraits of the artist's parents, siblings, and extended family. We don't always have access to our family and relatives, but we usually have photographs of them lying around to use to make a portrait. For this painting, I wanted to make a portrait of my uncle. I found a photograph, taken a couple of years ago, that seemed to capture his personality: He was in the pool at a family party.

When working from photography as a source for a portrait, I find it's helpful to begin the drawing or underpainting as I would if I were observing the person in real life. For example, drawing a universal head shape or blocking in the planes of a skull before you look at the photograph for particular facial features will ensure that you get a volumetric, lifelike head rather than the flattened distortions typically found in images made from photography.

EXERCISE 34

Pick a photograph of a relative from your family photo album to paint. When working from the photograph, it can sometimes be helpful to make a black-and-white photocopy to use as well so that you can see the image purely in values and find shapes from lights and darks to use as reference.

TIP

When working from photography, it's sometimes helpful to have a model stand in for the subject, even if it's just for a brief moment during the underpainting so that you can actually observe the body position. Find someone with a similar build and pose him or her just like the subject in the photograph. Do a few quick studies before you return to the photograph.

Jim in Pool, gouache

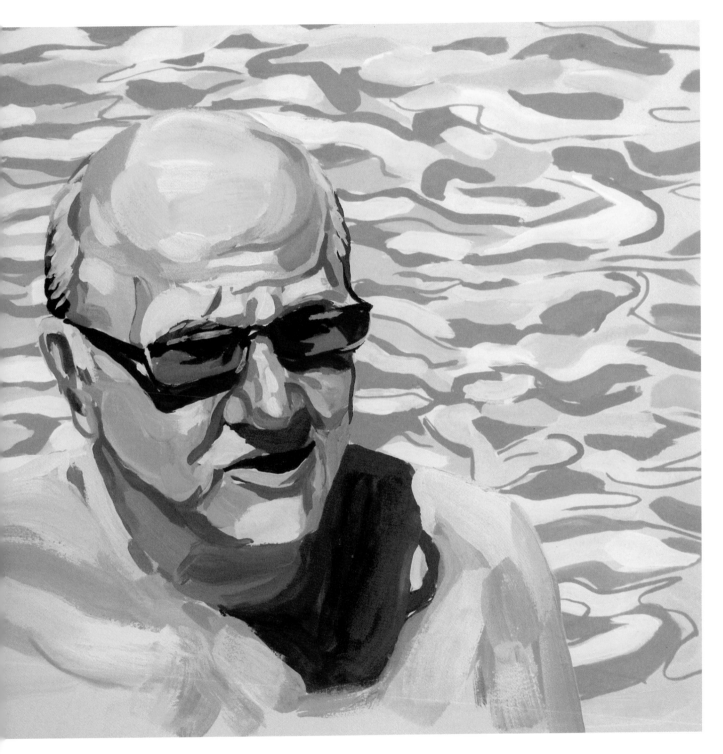

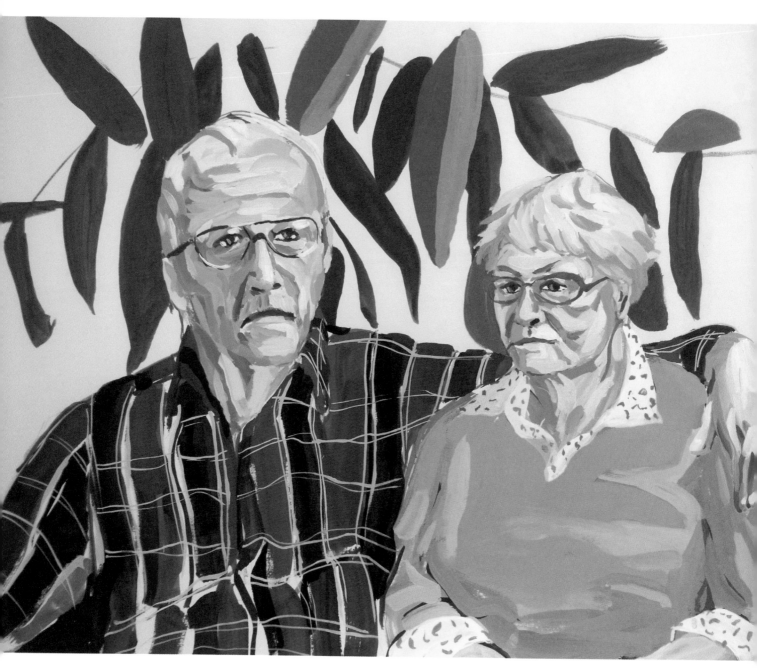

Oma and Opa, gouache

DOUBLE PORTRAIT
DAY 35

Painting two people, a classic motif in the tradition of portrait painting, is a very challenging exercise but also has unique advantages over the single portrait. One obvious advantage is that you can keep working while one of the subjects takes a break to stretch. It is important, however, that during the beginning of the portrait, when you're sketching out the composition, both subjects are present to ensure unity in their gesture and the spatial relationships between the two figures. I find it helpful when painting a couple to look at them as one single unit. During the underpainting, when laying in initial colors (like the cool blues and violets for shadows and warm yellows and oranges for highlights, as mentioned in the section "Intimate Portrait"), use the same colors for both subjects to emphasize the unity. For this painting, I asked my partner's grandparents to sit for a portrait in their home. Similar to the discussion of casual portraits earlier, I had a limited time in which they could sit for the portrait, so I applied some of the same tactics and spent much of the time focusing on their faces.

EXERCISE 35

Ask a couple you know to sit for a portrait. You can have them come to your studio or ask where they would like to be painted. During the process, make sure to take a reference photograph if time is an issue.

TIP

To further ensure the unity between the two subjects in the painting, build up the painting systematically and with an even amount of time spent on both figures. For example, it's not a good idea to finish one of the subjects before moving on to the other one.

VARIATION

This might be a good exercise to use invention and completely invent a portrait of two people. In Amy's painting she presents us with a fantastical image of twins which is a great subject for a double portrait.

Twins, Acrylic and Resin, by Amy Kligman

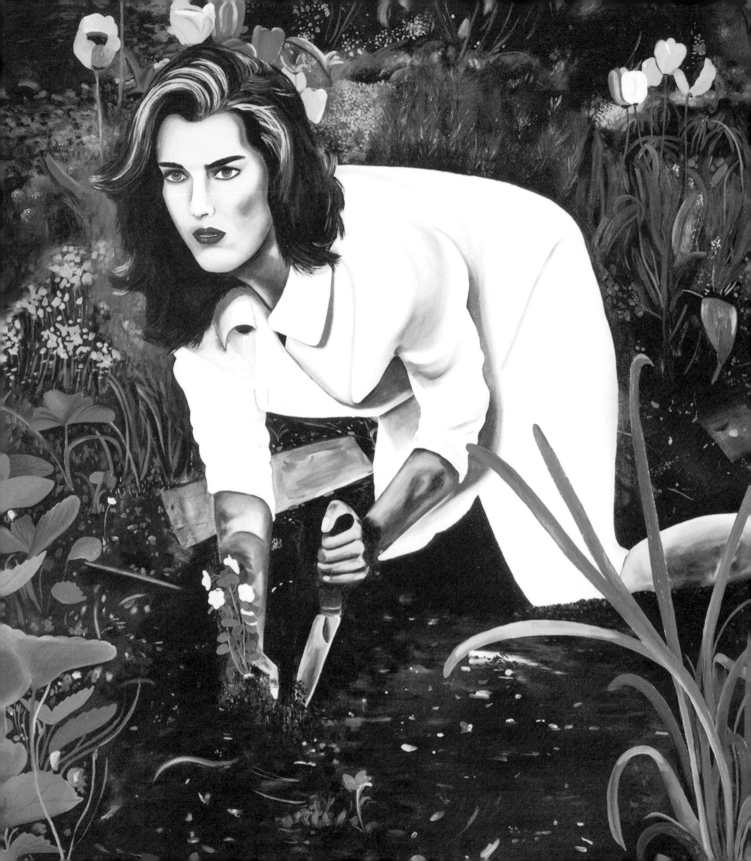

NEW DIRECTIONS

The genre of portrait painting has many different avenues and themes to explore beyond the tradition of an observed painting of a seated subject. The presence of portraiture in contemporary art continues to be relevant, constantly redefining itself.

A portrait combines still life and landscape with the human element—a figure in space interacting with objects. A portrait can also tell stories through gesture and environment as well as light and color. A portrait's subject is usually a person, but it could be an animal that has "personality" or even a group of objects that embody a person.

One of the most exciting things about painting is that there is no limit to what you can create on a canvas. If you're painting a portrait, you can push boundaries by inventing narratives about your subjects. In this final chapter, we combine the format of portraiture with all the experiences from the previous exercises to make imaginative paintings about the human element.

Brooke Shields in Burberry,
oil, by Libby Black

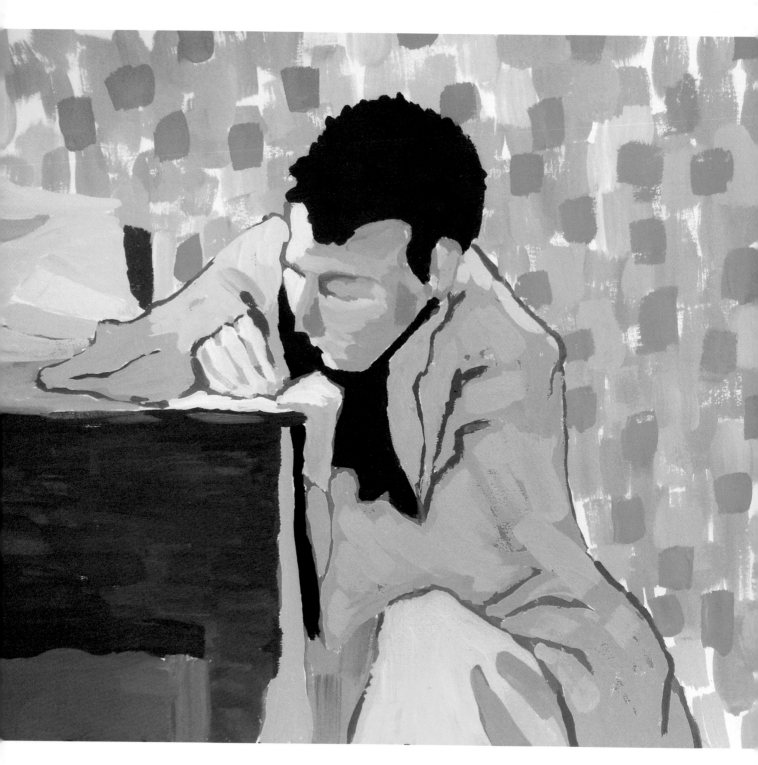

HISTORICAL PORTRAIT
DAY 36

Painting has a long tradition of homage and studying the masters' works. Most painters at some point in their formal training have copied the work of a master or painted homage to an artist they admire. I have always admired Édouard Vuillard and frequently return to him for inspiration. His portrait of Lunge-Poe, one of his closest friends, is one of my favorite works of his.

Vuillard's approach to brushwork made a significant impact on me as a young artist. For this painting, I wanted to copy the mark making as accurately as I could. The only thing I consciously changed in the homage is the background. I have always loved how Vuillard handles negative space and pattern, so I included a bit of that in the reds and browns in the background to activate the red linear marks in the figure.

VARIATION

Another way to approach this subject is to choose a portrait you have always admired and use only the subject and composition as a source to remake the painting in your own style. In Harris's painting of van Gogh's *Head of a skeleton with a burning cigarette*, the iconic image is instantly recognizable, but it is executed in the artist's own style and approach to brushwork and color. This adds another level of humor to the already funny and macabre little painting.

Vuillard study, gouache

EXERCISE 36

Choose one of your favorite portraits to re-create and do a little research about the subject for inspiration. You can paint it in your own style or try to copy the artist's style.

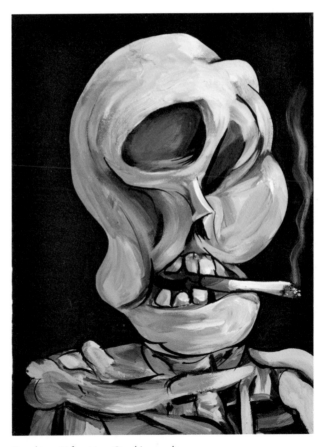

Smoking (After Van Gogh), acrylic, by Harris Johnson

CELEBRITY PORTRAIT
DAY 37

The celebrity portrait is a motif that is as old as painting itself and continues to be relevant in contemporary painting. For better or worse, the idea of celebrity is ubiquitous in our culture, taking a lot of effort to ignore. Many artists continue to respond to it.

The idea of "local celebrity" is an especially fun one to play around with; typically they're figures that everyone in your town recognizes but do not garner much attention outside the city limits. For this painting, I set out to make a portrait of one of Cleveland's local weathermen, Dick Goddard. He's a curious and funny figure who has been on the air longer than most of us can remember. I found a picture of him on the Internet that I decided to work from because it seemed to be a little more candid than most. My painting focused primarily on his intense gaze, emphasizing the redness of his eyes.

EXERCISE 37

Choose a celebrity that you find fascinating to depict in a portrait. Look for a photograph or two to work from that you think best capture that celebrity's personality.

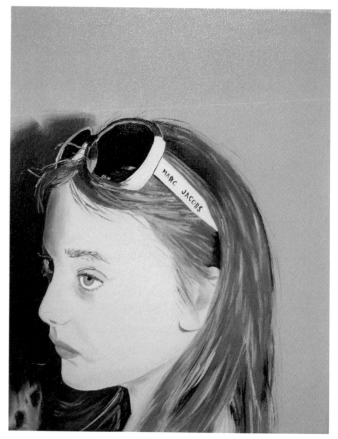

Dakota Fanning, oil, by Libby Black

VARIATION

Fashion advertising, especially the high-end sort that attempts to humanize celebrities, is great as a source for candid celebrity photographs. In Libby's painting of Dakota Fanning, she used a Marc Jacobs ad that depicts the star in a more casual composition than you would find in a "head shot" of the actress.

Dick, gouache

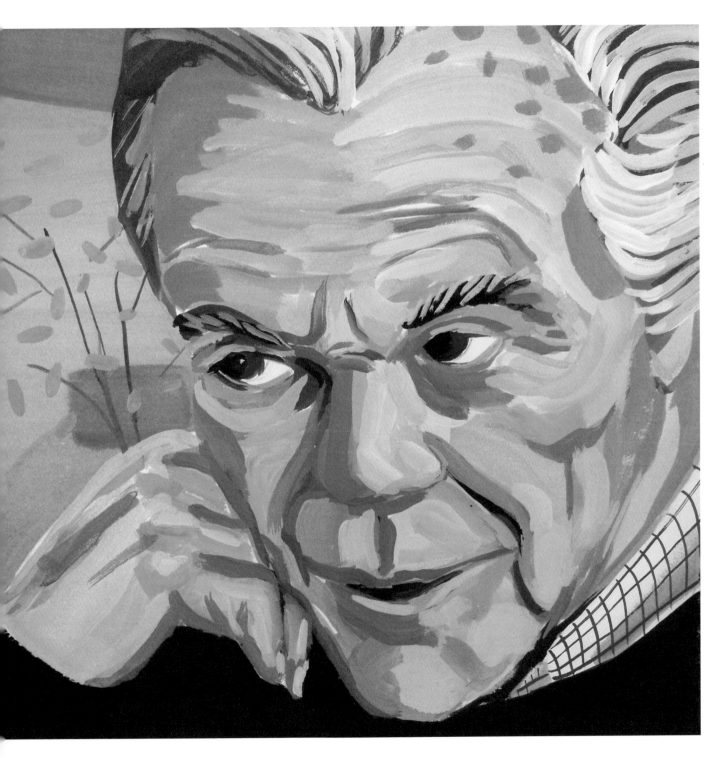

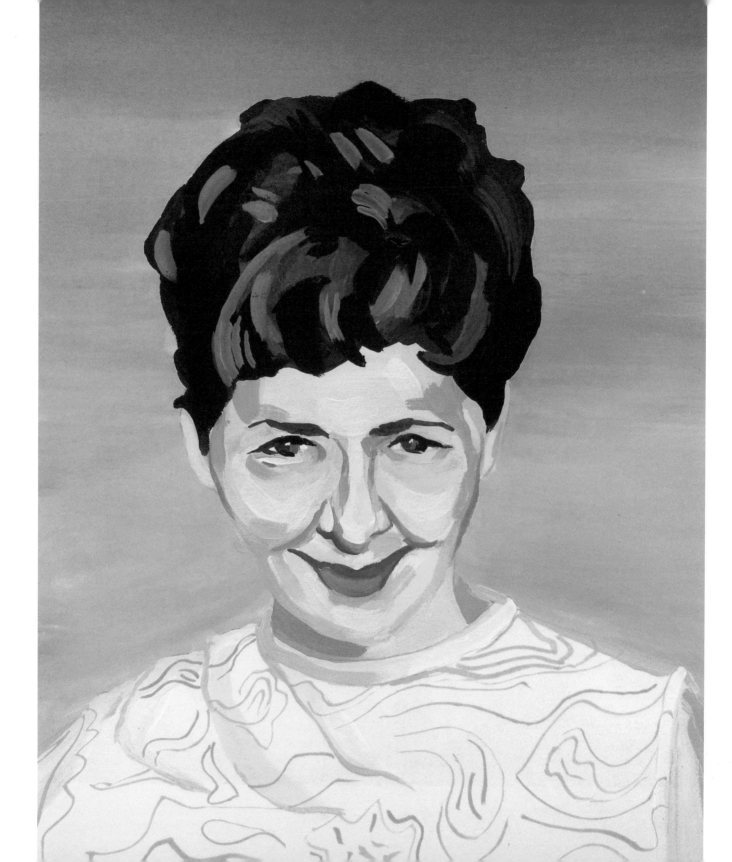

STRANGER PORTRAIT
DAY 38

Living as we do in the digital age, the number of images we see on a daily basis can sometimes be overwhelming. On television, the Internet, and smartphones, we see hundreds of pictures a day. Chances are good that at least half of those images include faces of people who are complete strangers to us.

It can be fun to create a portrait of a stranger, using the countless images that you come across in a single day. I found an image of this woman in a discarded family photo album and was immediately drawn to her face and expression. Who is she? What did she do? Is she still alive? You can attempt to answer all these questions by simply re-creating the portrait in paint. I applied many of the techniques from previous exercises on working with a photograph, using the image only as a starting point, then allowing my imagination to fill in a lot of the details concerning color, light, and pattern.

EXERCISE 38

Find a picture of a person who is a complete stranger to you. Allow your imagination to take over at some point during the process and abandon the photograph. Finish the painting with your own decisions about details like clothing and maybe background, based on a narrative you have invented.

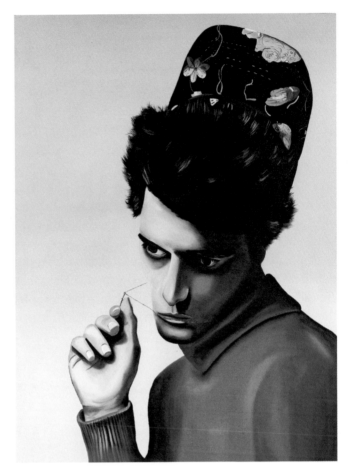

Boy with Hat, oil, by Libby Black

VARIATION

When you're working from a photograph of an unfamiliar subject, some elements from the photograph will be lost in translation and new ones will be added. A significant shift in scale from the source to the painting will intensify this. In Libby's portrait *Boy with Hat,* the painting is significantly bigger than the photographic source, which allows her to exploit the tension in the image and make decisions on color and form that are completely imagined.

Still Searchin', gouache

PET PORTRAIT
DAY 39

If you're a pet owner, your pet is probably just like another member of the family—and has just as many portraits in the family photo album as any human family member. The sentimental connection and the animal form make pets great subjects to paint.

For this painting, I wanted to make a portrait of my cat in her favorite spot on the kitchen table next to the window. I started with a few drawings in my sketchbook, and then took some reference photographs to work from as well. More than likely, you will have to use some photographic references to make a portrait of your pet. In addition, it may be helpful to do some quick sketches of your pet from life to better understand the anatomy of the particular animal you choose. The nice thing about using cats and dogs for subjects is that they tend to take a lot of naps, which is a perfect time to do drawings and make studies.

EXERCISE 39

Make a portrait of your pet. If you don't have one, borrow someone else's pet to work with. As an alternative, you could treat this exercise like a commission and collaborate with the pet's owner.

VARIATION

An interesting variation on this exercise is to change the format of your canvas to complement the type of animal you paint. Typically, a portrait format is a vertical rectangle, but in Cecelia's portrait of a Dachshund, she presents the image of the dog on an elongated horizontal canvas to emphasize the dog's most recognizable characteristic.

Weiner Dog, watercolor, by Cecelia Phillips

Hildy, gouache

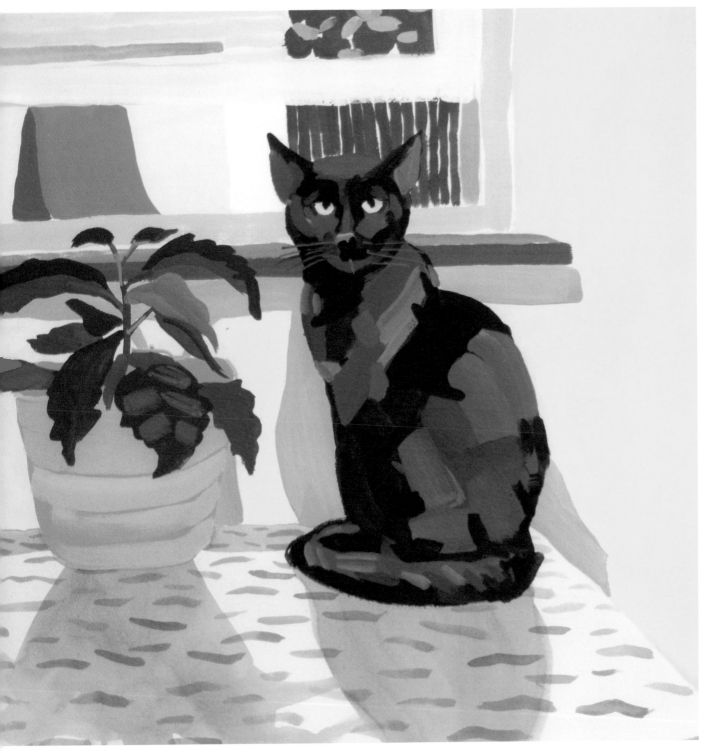

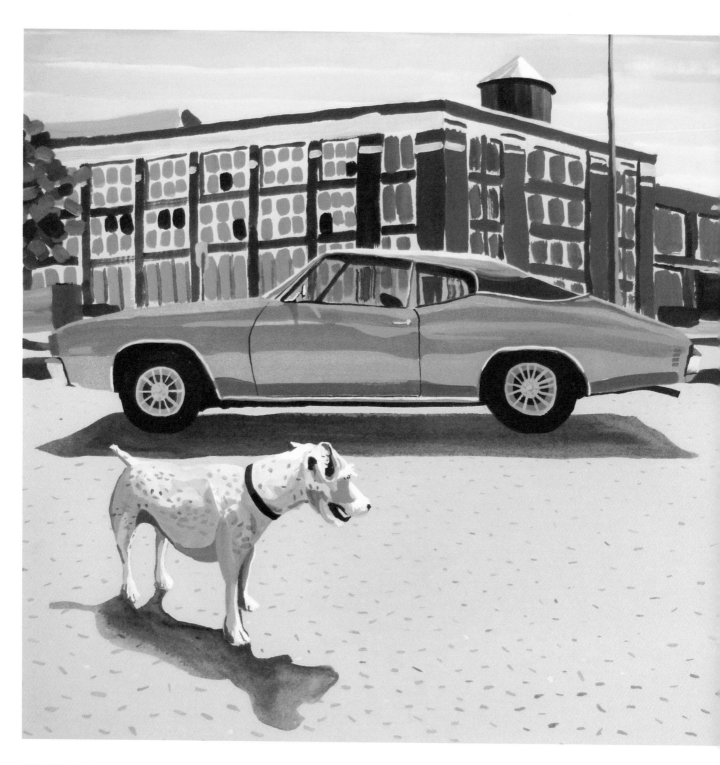

POSSESSION PORTRAIT
DAY 40

The things we own and are most proud of are representations of our personal taste and style. They are great subjects for a painting because they tell stories of our desires and our history. Just as we sometimes choose pets that reflect our personalities, the possessions that we are most proud of are typically those that mirror our personalities.

For this painting, I made a "portrait" of a friend's classic muscle car, a possession that was passed down to him and that he is extremely proud of. People often identify with cars because cars have many relationships to the human body in form and personality. The painting also works as a double portrait with the inclusion of the dog in the foreground, a detail I added last, mostly as a compositional element. Rather than choose a vertical format, I wanted to portray the elegant profile of the car, so I gave the painting a more horizontal landscape format. Including the dog at the bottom of the composition slightly overlapping the car reinforces the vertical read of the painting.

East Side, gouache

EXERCISE 40
For this painting, choose a favorite possession that you identify with and that has anthropomorphic qualities. Begin in the sketchbook doing a few different variations on composition; think about the differences between still life and portraiture in regard to orientation, vertical versus horizontal, and cropping the image.

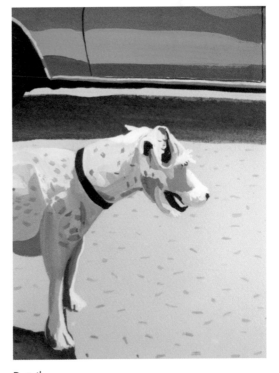

Detail

NARRATIVE PORTRAIT
DAY 41

A portrait has the ability to tell a story about a person. An interesting way to approach this is to come up with the story first and then build a painting around that narrative. It's almost like working in the reverse order of the portrait of a stranger. Rather than responding to a stranger's face and inventing a story to assist in filling in the details, come up with a story first and then find a subject who would best describe this portrait. I was people watching and eavesdropping on patrons in a local tavern one day and started thinking about a narrative of the quiet reflection at the end of a workday. A narrative portrait demands that you pay more attention to the details of the space and objects that the figure is interacting with. It's a fun exercise that allows you to work more like a film director. Choosing the elements of location, model, objects, and lighting that will help tell the story are all important details that should be carefully considered.

EXERCISE 41

Invent a protagonist and a micro-narrative about him or her that tells a story, and then work from that story. It could be as simple as something like "A guy walks into a bar and . . ." Begin with your sketchbook and camera, working out a few variations—almost like a storyboard. Choose a photograph to set up as a subject and a composition to use for this painting.

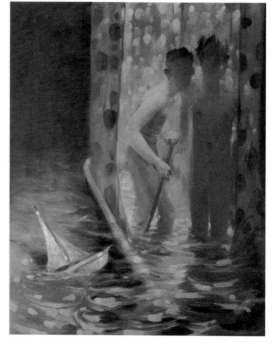

Steering a Sinking Ship, oil, by William Newhouse

VARIATION

You can let your imagination run wild with this exercise. Make it as fantastical as you like. In William's painting, the figuration comes first and then he makes decisions about space that fit the gesture of the figures to support the narrative elements. The flooded bathroom suggests a whimsical tale of steering troubled waters.

Off the Clock, gouache

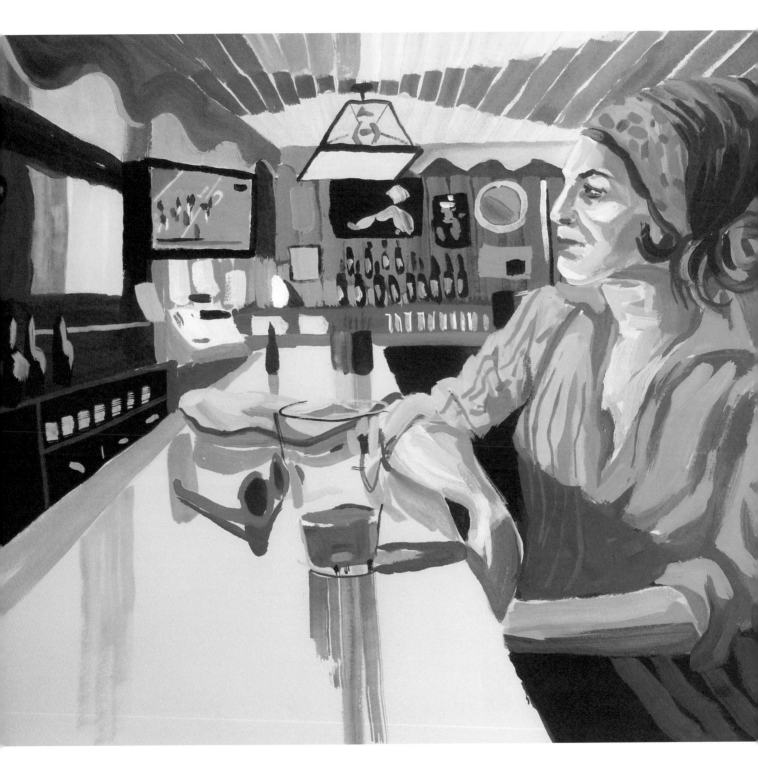

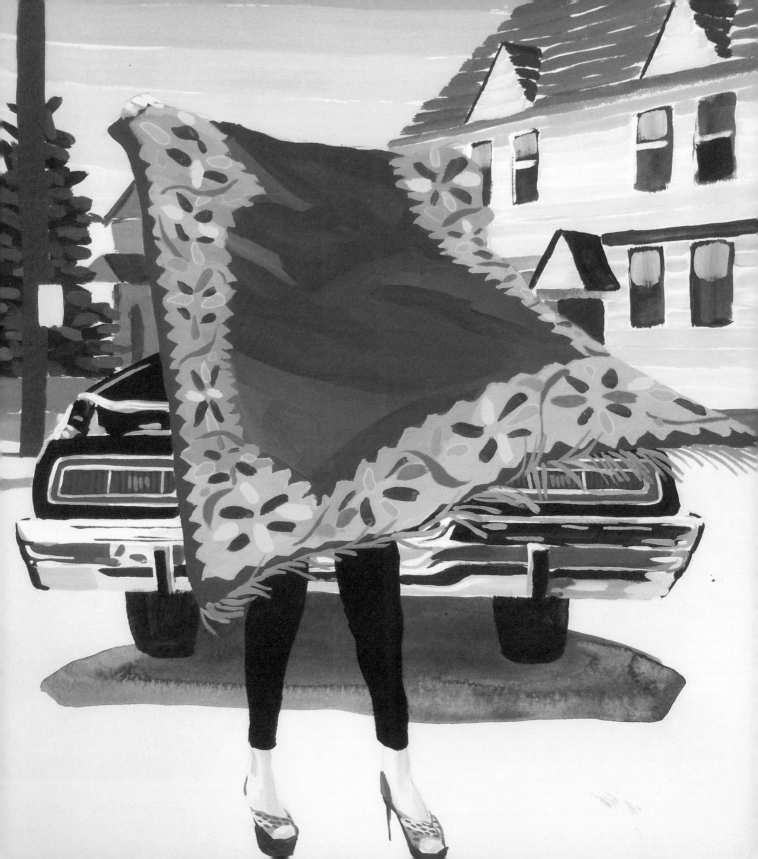

HIDDEN PORTRAIT
DAY 42

When someone simply mentions the word *portrait*, chances are the first thing that comes to mind is an image of a face. Likeness is typically credited to a person's facial features, especially his or her eyes. What happens when we eliminate the face altogether to make a portrait? For this painting, I wanted to challenge myself and try to create a portrait where the face was completely absent. Much like in the narrative portrait, the concept for this painting was conceived before I had a subject to photograph. I wanted the identifiable gesture of shaking the rug to be the subject of the portrait. After taking a few reference photos of the gesture, I had enough sources to piece together the painting. Only a few details refer to the person's identity: The figure's legs and high heels clearly indicate that this is a female. The rug itself and the obscured car just behind the woman are details that refer to elements of class, style, and even the urban environment that suggest the subject of this portrait.

EXERCISE 42

For this last painting, create a portrait without depicting the face. There are so many possibilities for this challenge. Start in your sketchbook and draw a few different concepts before deciding on a subject to photograph.

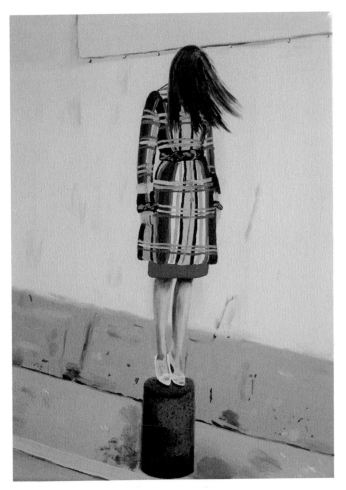

Standing on the Edge, oil, by Libby Black

VARIATION

You certainly don't have to hide an object or obscure the face for this portrait. How you pose your subject or the way in which the subject gestures could add an intriguing element to this theme. In Libby's painting, the hair of the girl she portrays does this quite elegantly.

Carpet Beater, gouache

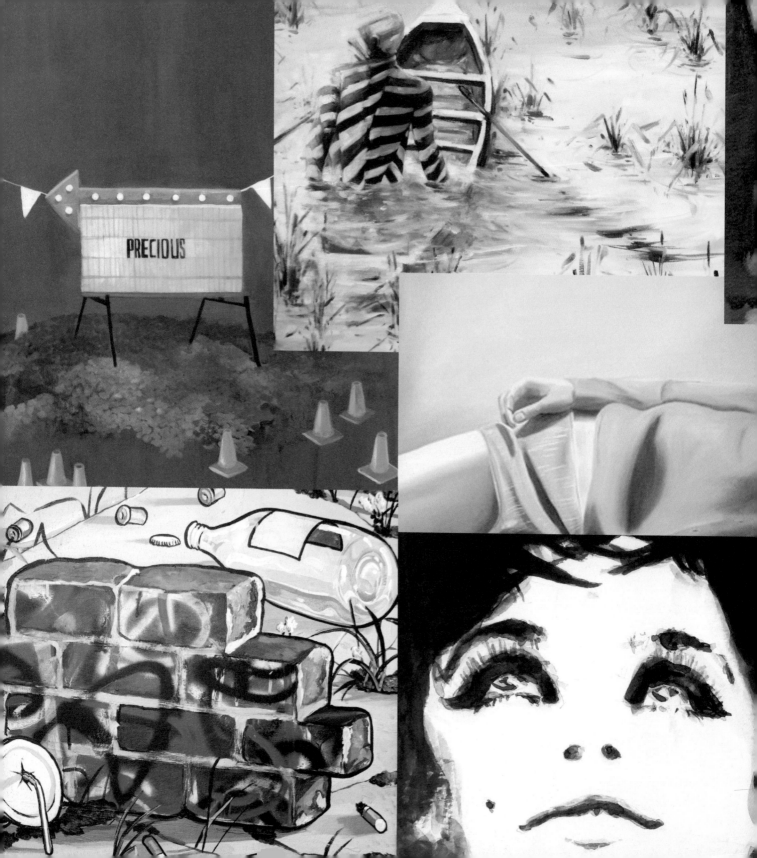

CONTRIBUTORS

LIBBY BLACK

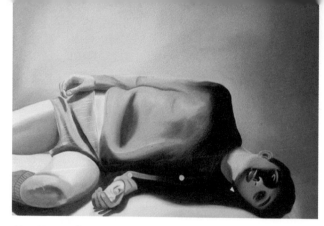

Miu Miu Underwear

Protest

Balenciaga

Libby Black is a painter and sculptural installation artist living in San Francisco. She has exhibited at Yerba Buena Center for the Arts, Orange County Museum of Art, Jersey City Museum, and numerous galleries in New York, Los Angeles, and San Francisco. She has been an artist in residence at Headlands Center for the Arts in Sausalito, and Montalvo Arts Center in Saratoga, California. Her work has been reviewed in *Artforum*, *Art in America*, *ARTnews*, *Zink magazine*, *Flash Art*, and the *New York Times*. She is represented by Marx and Zavattero in San Francisco. She earned a BFA at The Cleveland Institute of Art and an MFA at California College of the Arts. You can see more of her work at www.libbyblack.com.

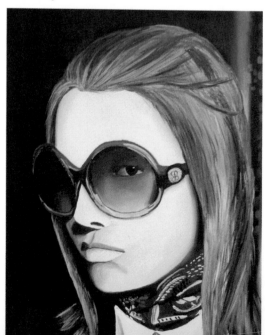

HARRIS JOHNSON

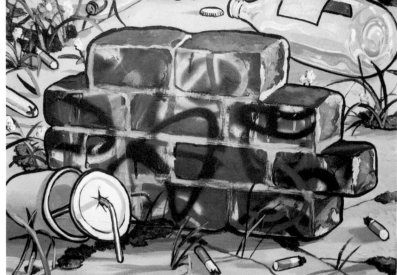

Parking Lot Sculpture

Harris Johnson was born in Columbus, Ohio, in 1986. He graduated from the Cleveland Institute of Art with a BFA in painting in 2009 and a certificate from The Burren College of Art in Ballyvaughan, Ireland. He has exhibited his work in Cleveland as well as internationally in Ireland. His works have also been featured in online exhibitions, and are held in numerous private collections. He lives in Cleveland Heights, Ohio. You can see more of his work at www.freeharrisjohnson.com.

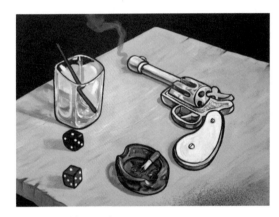

Gun on Table (Roulette)

Painter's Hand (After Pete Claesz)

MATTHEW JOHNSON

Matthew Johnson is a painter who lives and works in New York City. Originally from Memphis, Tennessee, he graduated from the Cleveland Institute of Art in 1998. He has exhibited his work in Memphis, Cleveland, and New York City. His art is usually formal, but the result, or at least the aim, is to arrive at something "other." Strange relationships, weird montages, happenstance, and precariousness are privileged characters within the work composed of shape, color, and line. All are compiled and composed within the picture plane in hopes of achieving the desired goal of finding function in the offbeat. You can see more of his work at www.matthewjohnsonart.com.

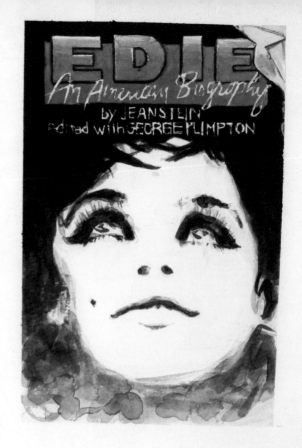

Edie

Inches Off

Postcard

AMY KLIGMAN

Amy Kligman is a painter living in Kansas City, Missouri. She exhibits her work nationally in group and solo exhibitions, and has been featured in many print and online publications, including *New American Paintings*, *Design for Mankind*, and *Boooooom!* She also codirects Plug Projects, an artist-run exhibition space. You can see more of her work at www.amykligman.com.

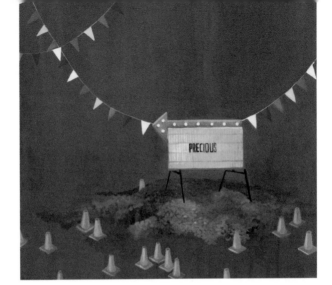

Precious

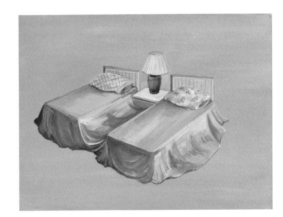

Pillow Talk

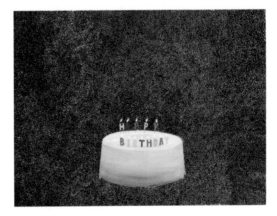

Unbirthday

WILLIAM NEWHOUSE

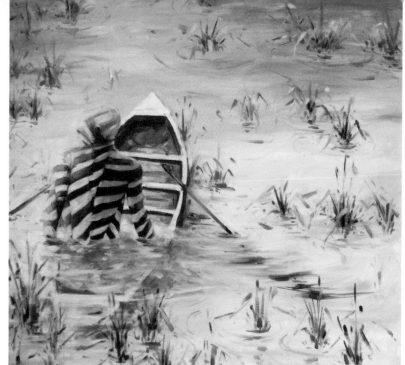

Sound of Constant Fog

William Newhouse is a painter and designer who lives and works in Chicago. Born in Wisconsin, he studied painting at The Cleveland Institute of Art and in Newcastle upon Tyne, England. He has exhibited his work in Portland, Oregon; Chicago; and Cleveland. You can see more of his work at www.williamnewhouse.net.

The Meeting Place

Safe Passage

CECELIA PHILLIPS

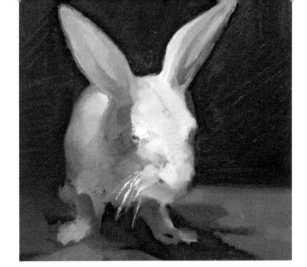

Untitled

Cecelia Phillips was born and raised in Rochester, New York. She graduated from the Cleveland Institute of Art in 2005, then moved to Austin, Texas, where she currently resides. She has shown her work in Texas as well as nationally, and is represented by William Busta Gallery in Cleveland. She paints and collects rocks, minerals, and cats, and spends her free time hiking the outdoors. You can see more of her work at www.celiaphillips.com.

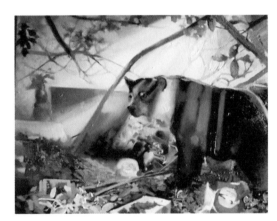

Lost

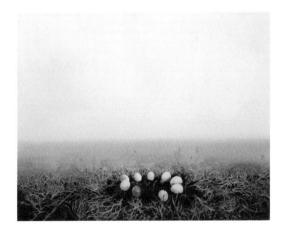

Satellite

ABOUT THE AUTHOR
TIMOTHY CALLAGHAN

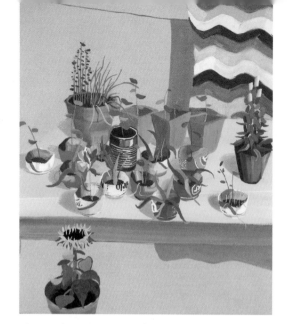

The Restless Lovers' Garden

Timothy Callaghan is a painter who lives and works in Cleveland. Born in Toledo, Ohio, he relocated to study painting at the Cleveland Institute of Art. He received an MFA from Kent State University. He has exhibited his work in New York, Philadelphia, Washington D.C., and Cleveland. His paintings are in various public and private collections, including The Cleveland Clinic. Aside from painting and writing, he also teaches art at Cuyahoga Community College and has been a visiting artist and lecturer at The Cleveland Institute of Art, Oberlin College, and Savannah College of Art and Design. He is represented by the William Busta Gallery in Cleveland. You can see more of his work at www.timothycallaghan.com.

ACKNOWLEDGMENTS

This book was truly a labor of love and wouldn't have been possible without the following people. Thank you to my friends and contributors, whose work continues to inspire me. Thank you to my editor, Mary Ann Hall. Your patience, support, and suggestions have been vital. A big thank you to Dan Tranberg, a fabulous painter and writer, for introducing me to Mary Ann. Thanks to Laura Putre for making sense out of my words; I am admittedly a much better painter than writer! Thanks to William Busta—your support over the years gave me the confidence to take on a project like this. Thank you to Krista Tomorowitz, whose love and support during this process was indispensable. Finally, a special thanks to my mother, Judy Callaghan, who instilled in me a work ethic that made this book possible.